ILLUSION

ILLUSION

The Art and Craft
of Special Effects
for Still Photographers

Fil Hunter
Paul Fuqua

Focal Press
Boston London

Focal Press is an imprint of Butterworth–Heinemann.

∞ Recognizing the importance of preserving what has been written, it is the policy of Butterworth–Heinemann to have the books it publishes printed on acid-free paper, and we exert our best efforts to that end.

Library of Congress Cataloging-in-Publication Data
Hunter, Fil.
 Illusion: the art and craft of special effects for still photographers/Fil Hunter
 and Paul Fuqua.
 p. cm.
 Includes index.
 ISBN 0-240-80064-8
 1. Photography—Special effects. 1. Fuqua, Paul. II.Title
TR148.H86 1992
778.8—dc20

British Library Cataloging in Publication Data
Hunter, Fil.
 Illusion: the art and craft of special effects for still photographers.
 I. Title II. Fuqua, Paul
 77.8

ISBN 0-240-80064-8

Butterworth–Heinemann
80 Montvale Avenue
Stoneham, MA 02180

10 9 8 7 6 5 4 3 2 1

Printed in the United States of America

If it walks like a duck,
swims like a duck,
and quacks like a duck,
it may well be a chicken...

On the Cover

The chess piece was suspended by tungsten wire. The board was stenciled, with black spray paint through airbrush frisket material, on white transluucent acrylic, lit from below by red gell. The cloud was painted with canned spray paint on black matte board and placed far enough away to be out of focus.

The set was first exposed conventionally, with the hand in place. Then the hand, the board, and the cloud background were removed, leaving only the suspended chess piece. Using the camera to project the image of the chess piece, the outline of the piece was traced on black paper mounted on white translucent acrylic several feet behind the chess piece. After cutting out the tracing the resulting black paper mask was relocated behind the same white acrylic, using the image projected by the camera for registration. With the foreground lights off, the film was re-exposed by a light behind the mask to produce an outline glow. The lens was heavily diffused during the second exposure.

Model: Brad Strange, courtesy of Ann Schwab's Model Store
Chess Piece: Courtesy of Vencente Guerra

CONTENTS

Chapter 5 Laboratory Effects 103

High Contrast 103
Flashing 106
Color Saturation 107
Grain 108
Polaroid Transfer 110
Masking 114
Pin Registration 118
Electronic Image Manipulation 120

Index 127

ACKNOWLEDGMENTS

This book would not have been possible without the unstinting help of many of our friends, clients, and associates. To them we would like to extend our sincerest thanks. In particular we are grateful to

Steve Biver for his infectious creative energy and the use of several of his photographs and props

Matt McMullen for his help with painted backgrounds

Frank Rogers for his assistance in preparing the section on prosthetic makeup

Bill Dempsey for his pictures and his help in putting together the section on model making

Dick Dodge, Jennifer Arnold, and the staff at Dodge Color, Inc., for their assistance with the section on electronic image manipulation

Tengrove Studios for the loan of a number of props and chemicals

William Neyman of Adroit Prepress Associates for his help with the illustrations

Washington House Photography, Inc., for assembly of the Rejuvenation picture

Jeff Mathewson for much vital help in all phases of the project.

ILLUSION

INTRODUCTION TO SPECIAL EFFECTS

This book is about the techniques photographers use to alter reality: to make less realistic pictures of real things and to make completely realistic pictures of impossible things. The book itself is a toolbox. Like most other toolboxes, it holds an assortment of helpful tools. In this case, the toolbox contains a collection of those special effects techniques we think are the most helpful to the working professional and the serious amateur photographer.

Some of the tools in this book are easy to use. These techniques are simple enough for any interested photographer to learn. Anybody can master them with a minimum investment of time and effort and, in most cases, with a relatively modest cash investment. Other tools require years of dedicated use to be fully mastered. Still others require equipment that is too expensive for almost all still photographers. But all of these techniques are worth learning about. For each photograph you do, pick the tools you want to use. Use the tools you master, and get the equipment you can afford; for the rest, buy the service from someone else.

Like any other box of tools, many of these are often used in combination with others. Just as mechanics frequently use both a wrench and a screwdriver to tighten a bolt, we must often use several techniques together to achieve the particular effect we want. Producing the effect we want is the fun part.

There is nothing particularly worthy about using a double exposure, adding some smoke, or making the subject float in space. Anyone can do it. If they cannot, they can certainly learn. Conceiving the image is the worthy part. A good photograph is a good photograph, regardless of how it got to be that way. (A bad photograph will not be improved by adding frills.) If the image you conceive requires straight photography, fine. But if the picture cannot be made by simply pointing the camera and shooting, regardless of the wisdom and skill with which you do it, here are the additional tools to put your concept on film or paper.

This is not a large collection of tools. It contains only about thirty techniques, and many are variations on others. After you have selected the ones you like, you will probably use less than half of the techniques described here. That will be enough to produce an infinite number of good pictures.

ORGANIZING OUR TOOLS

The special effects tools in this book can be gathered together in several broad groups. Divisions between them are not always clear-cut. Indeed, some of the techniques we discuss are hybrids that straddle the dividing lines between them. Other effects may be clearly in one group today, and clearly in another next week, depending on how we use them.

A photographer who is especially good at what we call physical effects, for example, may consider this group to be composed of several other major groups. The same person may rarely use optical effects and thus may not think they deserve to be the major category we have assigned to them. Instead, the physical-effects photographer may prefer grouping some of the optical effects as in-camera effects and others as laboratory effects.

Despite the problems of categorizing special effects, we nevertheless intend to categorize them. It simplifies discussion and makes it easier to write books. However, if you decide to reclassify anything, we will not argue with you. With that in mind, we have divided the special effects into four main groups:

1. **Physical effects.** These effects actually occur in front of the camera, although the subject *may* not be what it seems. A human viewer standing in place of the camera sees exactly what the camera would see. However, that viewer may realize that the monster he or she sees was created with makeup or that a street scene is, in fact, a table-top miniature while the *camera does not.*

2. **In-camera effects.** These effects also occur in front of the camera, but they take advantage of the *differences* between human and photographic vision to create a scene that is *different* from what a human viewer might see. These techniques are usually based either on the ability of film to accept repeated exposure or the one-eyed perspective of the camera.

3. **Optical effects.** Optical effects depend on the physics of light for their execution. Examples include using the optical properties of some materials to diffuse light and using the lack of depth of field to blend subjects. In using these techniques, the camera lens is sometimes used as a tool beyond a simple recording device, i.e., the camera may become an enlarger or a projector.

4. **Laboratory effects.** These effects are produced in the darkroom, and they require no camera (although one may be used for convenience). They include such techniques as copying existing photographic images to combine them and altering those images by manual retouching or by electronic processing.

COMBINING IMAGES

The techniques used to combine more than one existing image to make a single new one are perhaps the most important collection of special effects tools. Thus they rate some special discussion before we proceed further.

Front and rear projection, many masking techniques, and multiple exposure are some of the most widely used methods of combining images. Because combined images are used so frequently in special effects photography, it is vital to understand the key points that influence the effectiveness of the picture.

All combined images share the same objective: to convince the viewer that things that were never in the same scene really are. Even if viewers know that the scene in the photograph could never exist, we still want to convince them that it does.

Even if the picture is obviously a trick, the secret of the trick must never be revealed. Things that cannot happen—a frog turning into a prince or Jonah living in the belly of the whale—must look exactly the way they would look if the impossible event could happen.

Countless potential visual clues can spoil special effects and make them look phony. Combining images successfully requires looking for these clues and get-

ting rid of them. Finding the clues that expose the fake also teaches us what opposite clues enforce the illusion. We can then exaggerate the latter.

Some of these visual clues deserve special attention either because they are particularly revealing or because they are frequently overlooked by photographers who are beginning to learn special effects. All of them influence the psychological reaction of the viewer.

Because any photograph has perhaps hundreds of subtle clues to influence the viewer, the importance of any one of them depends on what else is happening in the scene. A clue that proves one picture to be counterfeit may pass unnoticed in another.

Regardless of the specific technique used, the following clues should be evaluated in almost any combined image scene. Photographers decide which clues impair the illusion, which ones need more work, and which can be ignored in each picture.

Lighting—The Most Important Clue

Lighting is the strongest single influence on the perceived reality of any combined image. It is largely responsible for the success or failure of any combined image. For that reason, we discuss several key lighting characteristics in detail in this section.

Some of the material is basic lighting theory, which has more to do with general photography than with special effects. If the theory is familiar to you, notice the special importance it has for combining images. If any of it is unfamiliar, a good basic lighting text may help you to combine images more expertly.

Lighting Position

The most visible characteristic is the apparent location of the light source. The key point to keep in mind here is that all of the elements in the scene need to appear as if they were lit by a single light source. This cardinal requirement means that all the subjects combined in a scene usually need to be lit from the same direction. Less obviously, those subjects also need to have the light source the appropriate distance from them. The following shows why.

Both of the subjects in **Figure 1** are lit by a small light source that casts a hard shadow. Both lights strike the subject from the same angle, but, one light is much closer to the subject. Look at the difference in the shape of the shadow. The difference may appear trivial in separate photographs, but it might reveal itself startlingly if we tried to combine the two images. Unsophisticated viewers might remain unconscious of the visual clue that the mismatched shadows provide. Nevertheless, they might feel that something funny is going on, and that uneasiness would cause the illusion to fail.

Lighting Contrast

Lighting contrast is determined by the amount of fill light and also by the contrast of the main light alone, regardless of fill. Photographers with little experience at controlled lighting can keep the ratio of main light to fill light similar in a series of shots of different subjects. However, they are more likely to forget about the contrast that the main light would have if it were used alone, so we will talk about it more.

Small lights produce hard, sharp-edged shadows. Large lights produce shadows with an edge so soft that we cannot see clearly where the shadow begins or

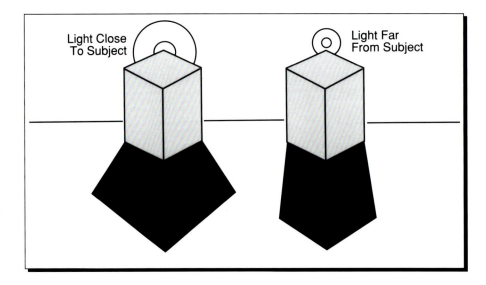

Figure 1 Although both light sources strike the subjects at approximately the same angle, the different dis-tances produce shadows of different shapes. This difference would prevent combining both in a single image.

ends. The hardness or softness of a shadow does not necessarily describe how dark it is. A hard shadow may be quite light if there is much fill light from an additional source; a soft shadow is always light at its edge, but it may be completely black in the center if there is no fill light.

Like the other lighting characteristics, the contrasts of the main lights need to match if combined images are to be believable. If two subjects are lit with sources of different effective size, the difference in the hardness of the shadows is an immediate giveaway.

Simply using light sources of the same physical size does not always guarantee that their contrast will be the same. A large light source produces soft shadows because it lights the subject from many angles simultaneously. Most rays do not enter the shadow area, but other rays from the same source illuminate part of the same shadow area. This means that the effective size of a light source is not determined entirely by its physical size. For example, the sun is a physically large light source. Nevertheless, it is so far away that all of its rays strike Earth at nearly the same angle and almost no sunlight goes directly into the shadow of a subject standing here. Subjects on Earth see the sun as a small source, regardless of its physical size.

Subjects in a combined image are often not at their natural scale relative to each other. This causes special problems for the unwary. We tend to place lights closer to small subjects and farther from large subjects for even illumination. This effectively changes the size of the main light. Overlooking this causes the subjects in a combined image to appear as if they were illuminated by different light sources even when the physical size of the light and its direction are identical. If we want to use a closer light source for a particular subject, we need to use a correspondingly smaller one. Similarly, a source farther away needs to be larger if the two arrangements are to match in the combined image.

Film Color Balance and Lighting Color
Film color balance may vary from one day's processing to the next. Lighting is frequently not of photographic standard color. Obvious examples are sunsets, fires, and television screens. Even studio lights reflected from surrounding surfaces can be some color other than white.

Figure 2 The photograph of a sub-ject illuminated by a very small light source shows a hard-edged, sharp-ly defined shadow.

Figure 3 A large light source illum-inates the subject from many angles. Some of the rays enter and illuminate the shadow. A shadow created by a large light source has no clearly de-fined edge.

Figure 4 The difference in the light-ing of the mechanic and the toy car destroys the illusion in this combina-tion photograph. The hard shadow of the car and the soft shadow of the man prove that the two could not have had the same illumination.

Human vision is not very good at detecting a slight shift in the color of light unless there is a similar subject lit by another light for side-by-side comparison. In that case, extremely subtle variations in color are detectable. Combined images present the viewer with exactly the comparison that most reveals color differences.

You are expecting us to suggest great care in maintaining color balance, and we do. However, for images that are to be combined, also try deliberately shifting the color of the light whenever it is artistically appropriate. Use the same gel on the lights for each of the images to be combined. Seeing light of the same color on several combined images reinforces the feeling that the scene is one even more than lighting the separate subjects similarly with the same white light. Color shifts caused by film and processing variations are less apparent in scenes lit by gelled lights.

Remember to pay special attention to the color of reflected light falling on the subjects. Because its effect is more slight, it is easier to accidentally ignore. This influence is often more apparent in the shadows. For example, shadows in a sunlit scene are often slightly blue from light reflected from the sky.

Subject Color

Limiting the color palette can unify the combined images. Keeping all parts of the scene generally warm or generally cool can make other differences less apparent. If artistic preferences or the nature of the subject prevent limiting the range of colors, colored light, described previously, makes diverse colors more similar.

Shadow and Highlight Placement

Subjects cast shadows on one another. A missing shadow proves that a subject was not originally in the scene. Conversely, if a shadow appears where the viewer thinks only the combined subject could have made it, the illusion becomes overwhelmingly convincing.

Like lighting color, shadow placement is a good visual clue to use to emphasize the illusion, not just a possible defect to avoid. Try to light the original subjects so that they would cast defined shadows on one another if they were in the same scene. Then use cardboard cutouts to produce believable shadows. Position the cutouts so that they are out of the area to be included when the images are later combined. If the physical arrangement of the subjects prevents producing appropriate shadows, retouch the shadow into the finished picture.

Similarly, the highlights on subjects need to be appropriate. This is especially important if one of the subjects emits light. Surrounding subjects need to be lit as if the luminous subject were really in the scene.

Perspective

Perspective is determined by viewpoint. Matching the perspective of two subjects means the camera must see both subjects from the same angle at the same distance. This seems simple enough until we realize that the camera does not see any scene from a single angle. Instead it sees each part of the scene and each subject in that scene from a slightly different angle. Furthermore, photographing subjects from the "same distance" is appropriate only if we do not intend to misrepresent

the size of the subject. If, for example, we want a picture of angels dancing on the head of a pin, we cannot photograph the angels (most of them are about two meters tall) from the same camera distance we use for the pin.

Matching the perspective of the images to be combined is much easier if we use the same film size and the same lens for each image. If technical requirements force you to change film size, use a proportionately longer or shorter lens. A 180mm lens with 4 × 5 inch film, for example, duplicates the perspective produced by a 360mm lens and 8 × 10 inch film.

Compose the photograph of the largest subject first. Mark the camera ground glass or viewfinder to show where the other subjects are to fit in the finished scene.

Because the camera sees subjects in different parts of the scene at different angles, ignore the angle to the subject and shoot each subject with the camera at the same angle to the ground. If any of the subjects are not to be on a level ground in the final scene, adjust the camera height accordingly. Raise the camera to simulate the view of a subject that is to be in a cellar, or lower the camera to get an appropriate view of one that is to be on a hill. As long as we keep the same camera angle relative to the ground, the angle to the subject will be correct.

Photograph each subject so that it is in the same position and the same size it would be if we were photographing the whole imaginary scene in a single exposure. If any subject needs to be larger to allow retouching, replace the lens with a longer focal length after positioning the camera with the shorter one. Changing focal length will not affect perspective as long as we do not move the camera. If the longer focal length lens crops the subject out of the image area, use a view camera and shift the rear standard to move the subject back into the film area.

These steps ensure that the perspective will be correct for any number of subjects in any position in the scene. If any subjects do not fit properly, it means that we are attempting an impossible perspective that could not happen even if the imaginary scene were real.

Sharpness

All of the combined images must have appropriate sharpness. This does not necessarily mean that the subjects should all be equally sharp. If the imaginary scene were real, lack of depth of field would usually prevent equal sharpness throughout. Background images combined with others are therefore more believable if they are slightly less sharp than foreground subjects.

Ideally, subjects to be combined ought to have roughly the same degree of enlargement from the original film size. The guidelines we gave earlier for perspective matching automatically provide images of the right scale. In practice, many advertisers routinely violate this ideal by replacing the image of their product in a "life-style" scene shot on roll film with a beautifully executed 8 × 10 studio shot of the product. If the product image is small in the scene, unsophisticated viewers do not notice the switch.

We need to pay special attention to the sharpness of the edges of the subjects in the combined images. Masking techniques need to produce edges that match the sharpness of any clearly defined lines within the subject. A mask that is good for a subject shot on 8 × 10 inch film may be too sharp for a subject on 35mm.

PRODUCTION SUMMARY

Yellow Spacecraft

The spacecraft model, about 8 inches long, was assembled from parts taken from several plastic hobby model kits for real spacecraft, aircraft, and boats. The background landscape was constructed of styrofoam, shaped by a blowtorch, textured with glue and sand, and painted.

The background was photographed first, with alcohol vapor fog and a yellow paper background, to produce a transparency to combine with the rest of the scene by in-camera masking. The final image required four exposures on one sheet of film.

Exposure 1: A rod covered with black velvet on a tripod dolly supports the spacecraft model from beneath. The gray paper background is unlit to photograph black. Rocks and alcohol vapor fog are added to the foreground and lit to match those in the background transparency.

Exposure 2: With diffusion on the camera lens, a single spot of light on the background produces a glow around the rocket motors.

Exposure 3: With the foreground unlit and the gray background lit to photograph as white, the background transparency is added to the scene by in-camera masking.

Exposure 4: A single shaft of light, focused and goboed to light only the path of travel, illuminates the spacecraft as its supporting dolly is pulled across the floor. Aluminum tubing attached to the floor guides the wheels of the dolly.

PRODUCTION SUMMARY

White Spacecraft

The toy spacecraft was supported by a rod from the rear. A light stand supports both the rod and the black cutout disk of the planet. The sheet of film received four exposures.

Exposure 1: The spacecraft is illuminated conventionally.

Exposure 2: With diffusion on the camera lens, a focused spot illuminates both the blue paper background behind the black planet and the silver foil disk attached to the blue background.

Exposure 3: A red gel is added to the light illuminating the spacecraft, and the camera is panned.

Exposure 4: Film is re-exposed in another camera to a pinhole star field of black paper on a light table.

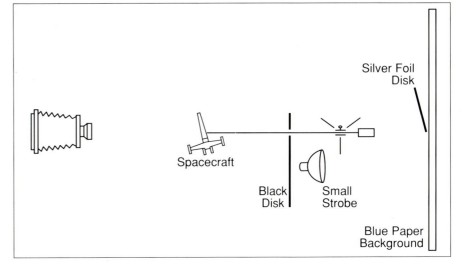

Depth

Most ordinary photographs have at least one element that extends through the scene from the foreground to the background. That element is usually the ground, floor, or table on which the other subjects sit. Scenes composed of several original images often lack such an element, and this causes them to appear to be a group of flat planes instead of a window into space.

Including a subject that appears in both the foreground and the background enhances the depth and the reality of combined images. A road running into the distance, for example, adds a feeling of depth to a scene. In a scene of combined images, depth strongly enforces the illusion that the separate subjects were all in the same scene. The blurred path of a moving object can serve this purpose well. Extending that path into the background and giving it perspective distortion conveys more depth than a similar path moving across the scene in a plane parallel to the printed surface. This is one reason why the picture of the yellow spacecraft is so superior to that of the white one.

If composition or technical requirements prevent any single subject from passing through the scene from front to back, consider repeating background subjects with similar subjects in the foreground. Seeing foreground trees, furniture, or mists like those in the background makes the layers of the scene less distinct.

Using short focal length lenses and close camera distances to exaggerate perspective distortion also strengthens the illusion of depth. However, the more extreme the perspective distortion is, the more closely the perspective of the combined images must match. Human perception is more willing to forgive perspective mismatch between combined images if the distortion in them is slight.

Generation Loss

Some image combination techniques require that part of the finished picture be a copy of the original that is at least one generation older than the rest of the scene. This always happens in in-camera masking and front or rear projection. Even techniques that do not absolutely require additional generations often use duplicate film in practice for convenient sizing or for the safety of the original.

The problem with generation loss is not simply the loss of quality. Careful exposure and filtration can minimize those defects. However, there will always be some generation loss, and it becomes apparent when we have earlier generation subjects in the same scene.

Using large format, fine grain film and using contrast reduction techniques, such as flashing, for any elements in the picutre that are to be duplicated helps to reduce quality loss, but does not eliminate the problem.

The ideal remedy is to keep all subjects in the scene the same number of generations away from the original. However, this solution is impossible with some techniques. In those cases, it helps to compose the photograph to minimize the importance of the multiple generation part of the scene.

Photographers who are inexperienced in in-camera masking or front or rear projection tend to be so impressed with the effect of the background that they let it dominate the scene with its compositional size or position. This emphasizes the generation loss. Covering most of the background with the primary subject prevents the viewer from noticing the generation loss as readily.

Be especially careful with background images that have large highlight or shadow areas with important slight gradation within those areas. Those are the

tonal values that most reveal generation loss. Backgrounds unfamiliar to most viewers, such as outer space or the ocean bottom, can suffer more generation loss without detection.

Camouflage

Viewers use so many visual clues to perceive reality that it is usually impractical to fool them with every detail. Anything that obscures imperfections can make combined images more convincing. Putting fog, smoke, or clouds in the image can help. Try double exposing a misty cloud over a suspicious edge. Lines drawn mechanically look less mechanical if they glow slightly. Diffuse second and third generation subjects enough to make the quality loss look deliberate.

Existing edges in any picture element can also be helpful in camouflaging composite edges. For example, if you needed to add a top floor to a building, we might use an architectural ledge to disguise the seam. Irregular patterns are also helpful in disguising edges. They help to conceal seams, supports, and other visual clues that might give the picture away. Mechanical supports are visible in both the Asteroid Mining and Yellow Spacecraft pictures seen elsewhere in this book. However, background camouflage makes the support unnoticeable to the viewer.

CHAPTER 2

PHYSICAL EFFECTS

Physical effects actually occur in front of the camera, though what the camera sees may not be what it appears to be. In one way or another, some part of the scene is faked. The fog rising from the graveyard may be carbon dioxide; the liquor caught in midsplash may be plastic; the swimming pool may be the size of a table top, not a backyard.

Physical effects are some of the most useful special effects tools. Their basic purpose is to create a manageable version of something difficult or impossible to control. We cannot photograph the same actor at the ages of twenty and fifty in a single day, but makeup can simulate age. We cannot build a twenty-first century space station, but we can build a believable miniature. We usually try to avoid setting the set on fire, but enough alcohol vapor fog can convince a viewer that we did.

Some of these effects, such as the creative use of smoke or hidden suspension, are quite straightforward, and their effective use is within the ability of anyone who wants to try them. Others, however, such as the building of realistic models, require a great deal of specialized skill. This skill requires practice and cannot be mastered simply by reading about it. We will talk about the more difficult effects enough to help you decide whether you want to begin learning them and, if not, what to ask for if you decide to hire an expert.

HIDDEN SUSPENSION

Sometimes what you do not see in a photograph is as important as what you do see. This is particularly true when it comes to supporting or holding objects in position before the camera.

The ice cream cone in **Figure 5** is an example. It appears to hang in space with no apparent support. This was essential for this picture because its intended use was a large poster. Putting the cone in a hand was out of the question, because gigantic skin pores and hairs are not appetizing. There is no easy way to set a thing with a pointed bottom on a table top, so the ice cream had to be supported some way, and the support had to be invisible.

We sometimes want to support the subject invisibly simply to emphasize it: a thing looks more important with nothing else in the scene to compete with it. On other occasions we use invisible support to create the illusion of movement through the air: a few glass fragments suspended by a thin line with a slight swinging movement simulate shattering, but it does so safely and allows each shard to be positioned for good composition.

The most common use for hidden support is probably to control the light on the subject and background independently. One technique where this is essential

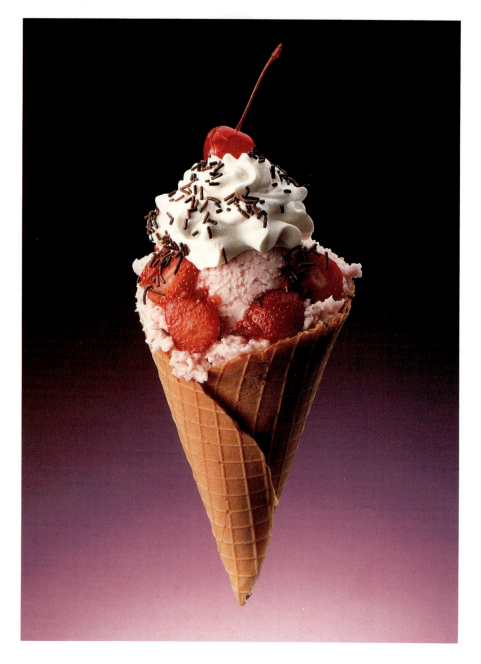

Figure 5 How does the ice cream cone hover in the air?

is in-camera masking. Positioning the subject and the background far enough apart prevents the illumination of one from interfering with that of the other.

There are four basic ways to conceal support. The advantages of each depend on the subject. The methods are:

1. A rear suspension rod
2. Suspension lines
3. A support concealed in shadow
4. A transparent support sheet

Rear Suspension Rod

The only method of support that is never visible to the camera is a rod through a hole in the background directly behind the subject. Almost any opaque subject can be supported this way. A thin rod commonly used to position a gobo is ad-

equate for many subjects. Two-by-four lumber screwed to a solid frame behind the background can support very heavy subjects. Use the thinnest support that will safely hold the subject to minimize the shadow of the support on the background.

Fragile subjects, such as the ice cream cone, present a special problem. Because the cone was made of pastry and would crumble easily, we could not just drill through it and bolt it to the support rod. The weight of the ice cream and toppings would have caused the cone to break apart. **Figures 6 and 7** show the solution to the problem. Silicon adhesive solidly attaches thin sheets of aluminum, bent to approximate the shape of the cone, inside and outside the cone. The result is quite strong.

If a subject is not easily drilled, hot glue may be used. This adhesive is melted and squeezed onto the subject by a hot glue "gun." The glue hardens to a bond upon cooling. Valuable subjects, such as electronics equipment and hand-built prototypes of future products, tax the imagination of photographers who want to support them on the end of a rod without gluing or drilling holes in them. In those cases, an L-shaped support, cut and bent to size by a machine shop, can

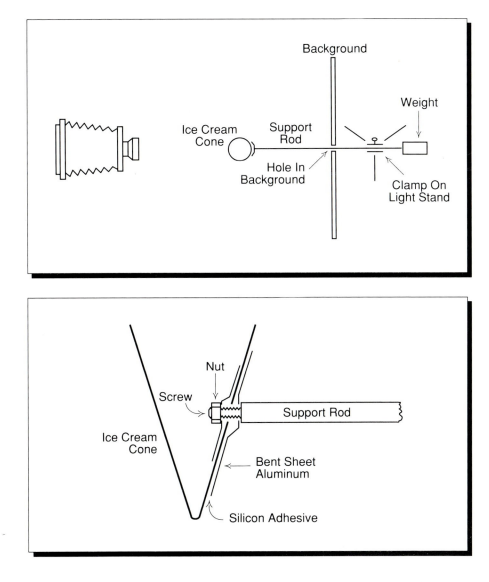

Figure 6 A rod through the background supports the ice cream cone. The ice cream blocks the camera view of the support rod and the back-ground hole.

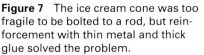

Figure 7 The ice cream cone was too fragile to be bolted to a rod, but reinforcement with thin metal and thick glue solved the problem.

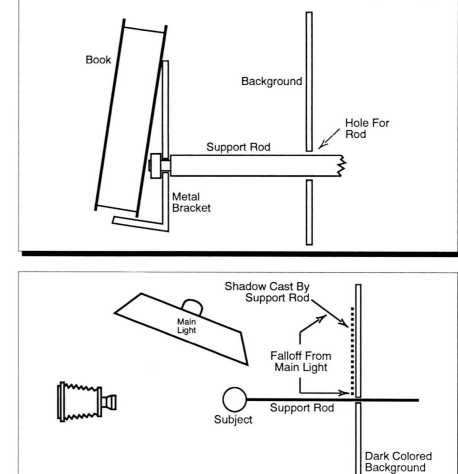

Figure 8 A simply made steel bracket bolted to wood can invisibly support a heavy subject. This also works for subjects too expensive to drill holes into.

Figure 9 The shadow of the support rod falls into the black background area. If that area is dark enough, the film will not record the shadow even though it may be visible to the eye.

sometimes be hidden under the subject. If the subject is a machine, we can sometimes temporarily remove screws from the back or the bottom and use existing holes to attach the subject to a specially built bracket.

Any of these techniques may allow the subject to move during exposure. Not only must we keep the support rod thin enough to conceal, we must keep it as thin as safely possible to minimize its background shadow. A fast enough shutter speed gets rid of blur during a single exposure, but cannot necessarily eliminate vibration effects if the subject has to register in the same place for a second exposure. Just remember that the one place where it does no harm to overbuild is behind the background. Even a thin support rod will vibrate less if it is solidly anchored.

Background Shadows

Support from the rear is easiest with a black background. If the background is not black, then it has to be lit, and the illumination can cause a shadow from the support rod. One way to overcome this problem is to arrange the lights to produce a falloff area in the background. As long as the exposure keeps the falloff area black, a shadow of the support in that area will not record on film.

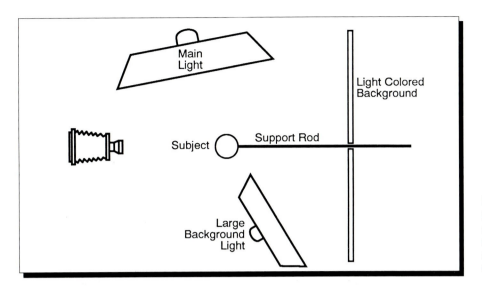

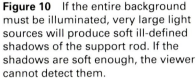

Figure 10 If the entire background must be illuminated, very large light sources will produce soft ill-defined shadows of the support rod. If the shadows are soft enough, the viewer cannot detect them.

Of course, there are, times when we need a uniformly lit, light-colored background. Using two lights, as shown in **Figure 10**, somewhat reduces the problem by adding fill light to the offending shadow. It is also important to use lights as large as practical. This is because the bigger the light sources are, the softer the edge of the shadow becomes. If the shadow edge is extremely unsharp, the viewer will not be able to notice it at all.

Suspension Lines

Some subjects cannot be supported from behind. They may be oddly shaped, valuable, fragile, transparent, or any combination of these. The sword in the picture of Merlin with Excalibur is another example. It would have been impossible to support it by a rod from the rear because the support would have had to pass through the actor. That would be somewhat difficult even for special effects experts.

The solution in this case was simple. We used thin but strong monofilament line, the same kind sold in fishing supply stores, to hang the sword in place. Fishing line is essential for heavier props like the sword. For lightweight props, alternatives to fishing line include magician's line, available from magic shops, and tungsten wire, available from people who specialize in special effects props.

In most lighting, tungsten wire is less visible than magician's line, and it allows more precise positioning because it does not stretch. However, tungsten wire is so difficult to see that it is hard to manipulate, and it breaks easily during handling. Any very thin line is difficult to knot. Instead, try securing it with a spot of Super Glue™ if the cost of the subject allows it.

Use three support lines from different angles whenever possible. A subject on a single line is a pendulum and may swing for an amazingly long time before it is still enough to photograph.

The thickness of the line and the ideal lighting of the subject left a slight trace of the support lines in the Merlin picture. A retoucher removed them, working on a dupe transparency. If the subject allows less diffuse lighting, gobos or grids may keep the light off the support line.

If the scene cannot be lit to keep the support line invisible, use either a white or black background whenever aesthetic needs permit it. Such tonally simple backgrounds are easier to retouch, and they also increase the chances of removing offending traces with a careful burn or dodge in the darkroom.

Whatever the solution, do not assume that retouching will be necessary and ignore the problem. A slight trace is easier to eliminate than a highly visible one. There are other times when the acceptable exposure turns out to be darker or lighter than expected, and that slight change in exposure keeps the support from being visible.

PRODUCTION SUMMARY

Merlin with Excalibur

This photograph was used to promote a series of books about myths and legends. The actor, in his mid-twenties, was aged by prosthetic makeup. The sword was suspended by nylon monofilament line. One sheet of film received three exposures.

Exposure 1: The actor and sword are conventionally illuminated and exposed.

Exposure 2: The actor is removed from the scene, white tracing paper is hung behind the sword, and diffusion is added to the lens. A black paper mask a few inches behind the tracing paper produces the glow around the sword.

Exposure 3: Film is re-exposed in another camera to a pinhole star field of black paper on a light table.

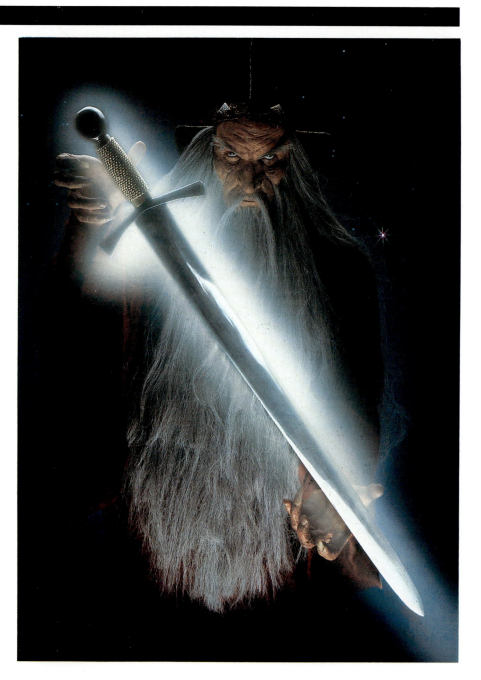

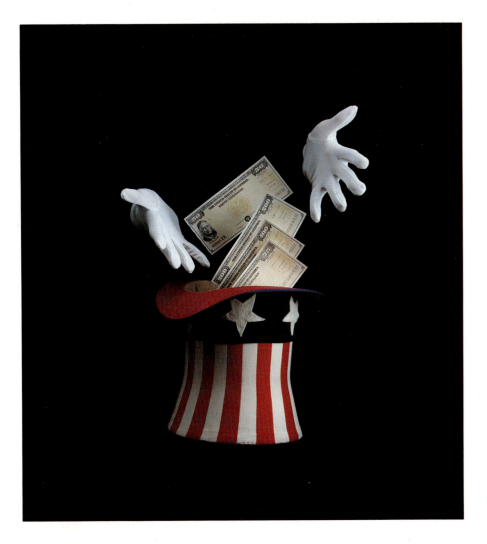

Figure 11 The magic of compounded interest.

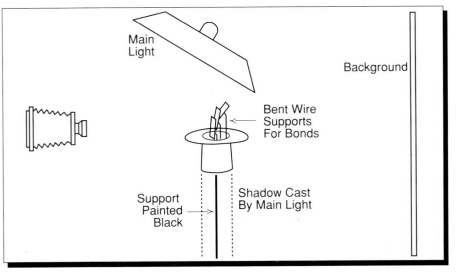

Figure 12 Careful lighting conceals the trickery. The shadow of the hat ensures that the black pedestal will not record on film. The magician, draped in black velvet, stepped into the scene just behind the main light and thrust his white gloved hands into just the illuminated area.

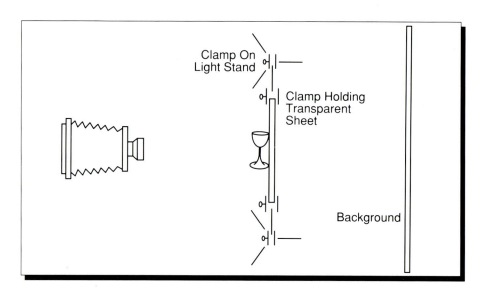

Figure 13 Gluing almost any subject to a transparent sheet will support the subject invisibly even if the subject is transparent. However, lighting must be meticulous to keep from producing reflections and revealing defects in the supporting sheet.

Support Concealed in Shadow

The support can sometimes be in clear view to the eye but will not be recorded on film. This requires a support that is painted flat black or draped in black velvet against a black background. Whenever possible, light these shots from above. This lighting casts the shadow of the subject on the support and keeps it dark enough to be invisible to the film.

Sometimes the shadows do not need to completely obscure the support. If there is enough distraction in the scene to camouflage the support, no one will notice a slight trace of it. The cloth-draped support is quite visible under the Yellow Spacecraft in the Combining Images entry, but it resembles the mountainous landscape too closely to be apparent to naive viewers.

Transparent Support Sheet

This method involves either laying the subject on or attaching it to a sheet of transparent plastic or glass. Use this kind of support when other methods fail. Although practical for almost any subject, it is difficult to light. Unwanted reflections, dirt, and fingerprints are always potential hazards of using a transparent support sheet. The best lighting for the subject often reveals these problems.

Nevertheless, there are times when a transparent sheet is the only good way to support the subject. **Figure 14** is an example of such an occasion. Any supports used to hold the pieces of broken glass in place would have been visible. The photographer, Steve Biver, solved the problem by attaching each falling piece to a clear glass sheet with Super Glue™.

ATMOSPHERIC FOG AND SMOKE

In this book we use the word *fog* to describe mist or particles in the air that are not produced by burning. This differentiates fog from smoke, which requires burning a fuel. In practice, however, the appearance of any particular fog is often identical to that of smoke.

The distinction between fog and smoke is important, not because they look different but because of nonphotographic problems associated with smoke.

Figure 14 The fish lived. Copyright Steve Biver, 1991.

Smoke is more likely than fog to affect the health or comfort of people on the set, and smoke in the air is more likely to damage or discolor equipment and props. Fog is a more pleasant alternative to smoke and should be used whenever there is a choice between the two.

The Effect

Atmospheric fog and smoke in varying densities can simulate clouds or natural fog and of course give the impression of fire. However, for many photographers, such literal uses are not the most common ones. We often use fog and smoke to camouflage, to diffuse, to produce background haze to enhance depth, and to reveal rays of light passing through the air.

It is rarely possible to fake reality in a completely believable way. No matter how hard we try, minor defects creep into our work—defects that can give away

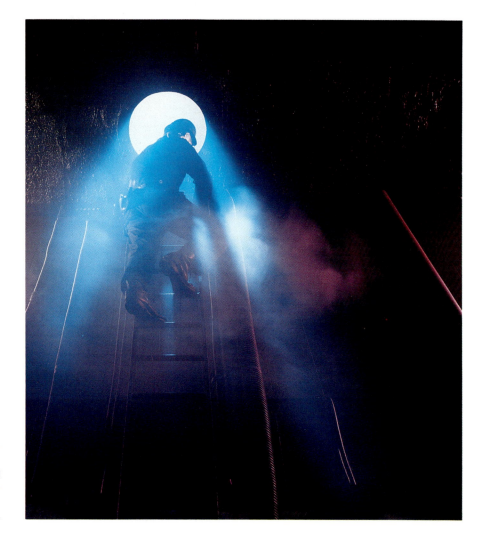

Figure 15 A 2000-watt quartz halogen fresnel spot illuminated the underground worker through the hole. The end of the ladder at the "top" is supported by a low saw-horse; the end at the "bottom" rests on the studio floor. The walls and ceiling were made of lightweight wall insulation board and taped to light stands. The actor, a body builder, was strong enough to hold the pose in a nearly horizontal position and to appear to be climbing vertically. The flimsy construction of the set reduced construction time and cost to the client.

the secret of the illusion. But a few puffs of well-placed smoke can protect the secret. Thick fog or smoke can hide what would otherwise be obvious trickery. A little of either can provide just enough diffusion to smooth out the rough edges and just enough softening of the image to lessen the reality a bit. The viewer then sees the picture as he or she might see an illustration, instead of a photograph, and refrains from the close inspection of detail that what would truly harm believability. Used in this way, fog and smoke may not be easily apparent in the scene. The only clue to their presence is a slight lightening and reduction in contrast in the shadows.

Such slight clouding of the air is almost essential for a miniature landscape. Even clean air has enough dust to create haze over a distant subject. If we want a studio mountain to appear miles away from a foreground subject, we have to put enough fog or smoke in the air to produce that same haze through only a few feet of air.

Finally, we also use fog or smoke when we need to make light rays clearly visible. A light source in a scene is visible, and so is an illuminated object that reflects its rays. But a ray of light through clean air is invisible because there is nothing to reflect it. The solution is simple: dirty the air a bit, put something in the path of the beam to reflect it.

Lighting Fog and Smoke

Both dry ice and alcohol vapor fogs have more opacity but are more reflective than many smokes and natural vapors. Depending on the effect we want, this can make them easier or harder to light.

For comparison, cigarette smoke and vapor from hot food both look good with back lighting, especially against a dark background. Each has enough transparency to let much of the light pass through. Because back lighting has less effect on other more opaque subjects in the scene, we can increase the light from the rear as much as needed to make the smoke very visible without over lighting the rest of the scene.

In contrast, the opacity of chemical fogs blocks too much light to allow the same results. If we want the fog to be bright, most of the light must come from the front. Because chemical fogs are more reflective, it is usually easy to get them as bright as we please with front light. However, lighting from the front does make it more difficult to control the lighting of the fog independently of that of the rest of the scene.

The opacity of dry ice and alcohol vapor fogs also means that we have to use less of them than when we used smoke to simulate background haze. Too much chemical obscures the background detail and quickly becomes noticeable even to unsophisticated viewers.

Finally, the opacity of the chemical fogs makes them much less suitable for showing rays of light passing through air. Unless the fog is distributed thinly and evenly throughout the room, dense patches of it block the light rays. The resulting photograph shows the ray fading away in the middle of the scene instead of continuing to its destination. A thin, even distribution of smoke is easier to use.

Hair dryers are useful for distributing relatively small amounts of fog to a thin haze. When trying to distribute larger amounts it is often helpful to direct the fog machine through an electric fan. This will spread the fog evenly through even a large scene.

FOG

Fog is generally preferable to smoke because of the relative lack of hazards its use involves. We now discuss some types of fog, how they are made, and what they are good for.

Dry Ice Fog

The cheapest and cleanest atmospheric fog comes from frozen carbon dioxide, or dry ice, dropped in hot water. No special equipment is required beyond a bucket, a chipping tool, safety goggles, and a pair of gloves, which should always be worn when handling dry ice. Carbon dioxide is abundant in clean air; we need not worry about harm from it except in very large amounts in closed spaces.

Dry ice fog is easier to control with a large volume of hot water and a small volume of dry ice. The more water there is and the hotter it is, the less dry ice is required to make the fog and the less the dry ice will cool the water.

The water container should be as large as practical, and it should be full nearly to the top. Because cold carbon dioxide gas is heavier than air, no vapor will spill out of the container if there is too much air space at the top.

Ideally, an assistant should control the fog while the photographer exposes

the picture. Chip off a small supply of dry ice pellets with a screwdriver or any other suitable tool. Using gloves or tongs, drop the pellets into the water at whatever rate maintains the right volume of fog.

Unfortunately, dry ice fog is not useful for every effect. Because it is heavier than air, it will not rise. This keeps it from realistically simulating clouds. Furthermore, the primitive method we describe here is impossible to control for a large set.

Dry ice fog machines make the technique controllable even for large sets. They essentially duplicate the process just described but with more precision. These machines have heaters to maintain water temperature and fans to direct the flow of fog. However, dry ice fog machines still do not produce a fog that rises. If you need to buy or rent a machine for an assignment, consider an alcohol vapor machine instead.

Alcohol Vapor Fog

The fog that comes closest to being usable for all effects is alcohol vapor. Producing this fog requires a machine designed specifically for the purpose. The alcohol is heated in a pressurized chamber. Opening a control valve allows the pressurized vapor to escape into the air, where it condenses in a mist closely resembling clouds or smoke. The mist is not poisonous and is unlikely to damage most props.

The alcohol used in these machines is chemically related to the wetting agents photographers use for drying film and prints and to several other common alcohols. However, we should *not* consider substituting any liquid for the one the manufacturer sells for use in the fog machine. Aside from the possibility of damaging the machine, some normally harmless chemicals can become highly toxic or explosive when they are vaporized.

Because alcohol vapor fog rises like clouds or smoke, it does not usually resemble low-lying natural fog. If we specifically want that effect, we can attach a basket of dry ice or ordinary ice where the vapor exits the machine. Cooling the vapor causes it to descend instead of rise.

Other Chemical Fogs

Photographers and special effects stylists continually experiment to find more convenient and more controllable ways to produce fog, and some of these ways find their way to market. It pays to be alert to alternate methods, because no one method is equally suitable to all needs. However, some alternative methods are much more hazardous than the dry ice and the alcohol vapor fogs described earlier. For example, some photographers drop small amounts of nitric acid and sodium hydroxide on food to make small curls of smoke. This works, but the individual chemcials are highly caustic, and in larger quantities the combination produces enough hydrogen to explode. If you do not know the chemistry, know the maker. Buy only from suppliers who conscientiously test their products for safety.

Some commercially available chemicals produce fog when they are exposed to air or humidity. One particularly useful example is the *smoke tube*. Available from special effects suppliers, these are small, chemical-filled, glass tubes with a small length of thin rubber tubing attached to one end. When you blow through the tube the moisture from your breath combines with the chemical in the tube. The result is a very distinct curl of smoke that is easily positioned exactly where you want it in the picture.

Figure 16 The books are on small boxes on a transparent sheet, with fog blown under them from the front of the set. The paper background visible through the transparent sheet is several feet under the books and lit with colored gels.

SMOKE

Smoke includes all those effects that are produced by burning. Although it is an irritant, smoke is sometimes better to light than fog. It also can be produced with little or no special equipment. This makes it available to photographers who do not need the effect often enough to merit buying a fog machine.

A Word of Warning

At this point, a word of warning is in order. No matter what the circumstances under which it is used, fire is always a hazard—whenever and however you use it. It burns people. It burns props. It burns studios to the ground.

So, stay alert. Have fire extinguishers handy and be absolutely sure that you completely extinguish any burning material when you are through with it. Safe storage is another consideration. Many municipalities have very strict rules about

how flammable materials may be stored, particularly in commercial buildings. It pays to be sure you are in strict compliance with them. These safeguards seem simplistic, but they can prevent a routine shoot from turning into a disaster.

Finally, a few smoke-making techniques require a licensed fireworks technician and a fire department permit for the day and place of use. Hire the technician. Do not attempt to use these methods yourself unless you have personally satisfied the fire department requirements.

Making Smoke

There are a number of ways of producing smoke. They range in complexity and expense all the way from simply dribbling oil on a hot charcoal briquette to using a factory-made smoke machine. The choice depends on needs, budget, and availability of smoke machines and chemicals.

Smoke Machines

For a lot of thick smoke under closely controlled conditions, there is no substitute for professional smoke machines. Plug them in, turn them on, and that is all there is to it—all the smoke we need at the push of a button.

Several different makes of smoke machines are available. However, they all work in the same basic way. They all heat some kind of "smoke oil" and blow the resulting smoke out of a nozzle. Convenient, efficient, and easy to use, smoke machines suffer from one major drawback: they are expensive. Fortunately, however, rental units are available in many areas.

These machines use a light mineral oil or glycerine, but you should buy chemicals only from the maker of the smoke machine. Unless the manufacturer recommends a substitute, do not try one, even if the factory chemicals seem overpriced and even if your best friend assures you that his homemade recipe is perfectly safe. Chemicals specifically made for use with smoke machines are not only effective but they are also safe to use. The last thing we need is to spray the set with a toxic or an explosive brew.

Smoke Bombs, Pots, and Cookies

Several different kinds of smoke bombs, pots, and cookies are available from theatrical suppliers and special effects prop houses. All they require to operate is a match or some other means of ignition, and the result is dense clouds of smoke. Many of these devices are available in varieties that make smoke of several different colors.

Smoke bombs, or canisters, are available in a number of sizes and burning times. They are made rather like fireworks. Once their fuses are lit, or ignited electrically, they pour out large quantities of smoke.

Cookies look rather like candy bars. When lit at one end, they smolder for several minutes giving off dense clouds of smoke. If we only need a little smoke, we can break off part of the cookie and use it.

Smoke pots resemble a heavy gauge cat food can. They are used with specially manufactured smoke powders that are lit with an electric match. The more powder used, the more smoke they produce.

All of these devices are made for outside use where there is plenty of ventilation. Because the smoke they produce can be irritating and even toxic, they should never be used inside. Because these devices all rely on the burning of some type of material to produce their smoke they can present a marked fire hazard,

depending where you use them. One way to keep this hazard to a minimum is to use these devices in a metal tray filled with a couple of inches of sand. This extra prevention greatly reduces the risk.

Flares

For some uses, such as giving the impression of flame, it is good to have light coming from the same source as the smoke. In these situations, a flare may prove useful. Flares come in different kinds, ranging from those commonly used to warn against hazards to those specifically designed to provide photographic effects.

Like smoke bombs, cookies, and pots, flares should only be used outdoors where there is plenty of ventilation, and they should be placed in a metal pan filled with a couple of inches of sand whenever there is any chance that they could cause a fire.

Other Smoke Makers

The smoke machines and the other manufactured devices are the best way to get a lot of smoke. However, there are many times when a little whiff is all that's needed. When that is the case, we usually rely on one of two simple and inexpensive techniques: oil on a charcoal briquette and oil on a heated wire.

Charcoal Briquettes For simplicity, this way of making smoke is unbeatable. All we need is a charcoal briquette, ideally the self-lighting type, some mineral oil, an old tin can with punched holes for ventilation, and a few stones or a bit of wire mesh. Using these materials could not be easier.

To start, put a few stones or some folded wire mesh in the can to keep the briquette away from the sides and bottom. Next, light the briquette and wait for it to get very hot. Once the briquette is glowing, drip a little mineral oil on it. The result will be clouds of white smoke that last for two or three minutes. To make the smoke last longer, drop a little more oil on the briquette. For a larger volume of smoke, use more briquettes.

Hot Wire Smoke Maker This is another simple device for making small quantities of smoke. It requires only a length of wire, a bit of fiberglass insulation (used for furnace filters and attic insulation), an automobile battery or a high-amperage, low-voltage transformer, and a little mineral oil.

Wrap the wire around the fiberglass. To make smoke, attach the ends of the wire to the battery or transformer, and drip mineral oil onto the wire and into the fiberglass. The hot wire quickly heats the oil-impregnated fiberglass enough to produce smoke. Disconnecting cools the coil to stop the smoke quickly.

PROSTHETIC MAKEUP

Prosthetics, derived from the Greek stem meaning "to add to," means artificial parts used to replace those not found on the body. In the hands of a skilled practitioner such as Frank Rogers, the makeup expert featured in these illustrations, we prefer to think of it more in terms of pure magic.

In special effects, prosthetics is a specialized kind of makeup. It involves adding false tissue to age the actor, to simulate wounds, to produce likenesses of famous people, or to create imaginary creatures. For years most prosthetics were made of various kinds of foam rubber. Today many makeup artists prefer to pro-

Figure 17 The actress with only straight makeup.

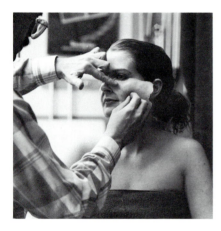

Figure 18 The makeup artist glues gelatin prosthetic pieces to the face of the actress.

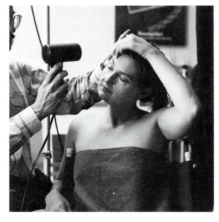

Figure 19 As the stippling dries, it wrinkles similarly to aged skin.

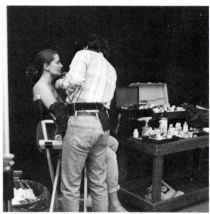

Figure 20 Makeup conceals color differences between the real skin, the prosthetics, and the stippling.

duce their wonders with different kinds of translucent plastics and natural substances such as gelatin. Foam rubber is more durable, but the newer substances are more lifelike. Base the decision on how large the prosthetic is, how active the actor must be, and how close the shot is.

The pictures above show the steps involved in a typical prosthetic aging session. These photographs are intended to show the general method—not to teach every detail. The skills require practice and experimentation. If you want to learn

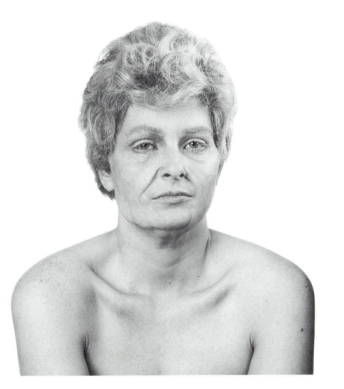

Figure 21 Warning! Makeup can do *this* to your skin!

them, this is a start. Otherwise, be aware that such things are possible and that people who know how to do them are available when you need them.

Figure 18 shows the makeup artist applying a gelatin prosthetic. In this case, the gelatin adds the masses of sagging cheek muscle tissue and bags under the eyes that are characteristic of older faces. The makeup artist is using a surgical adhesive that can be easily dissolved with alcohol when it is time to clean up.

In **Figure 19** we see stipple, a gelatin and liquid rubber combination that wrinkles in a lifelike manner when dried with a blow dryer. This technique is ideal for producing the age lines and crows-feet that are almost always present on older skin.

Once he has the prosthetic tissue masses in place, the artist applies a uniform layer of makeup to blend the real and false flesh together to produce the basic skin color. Finally, the local application of makeup of other colors creates the variation in color from one area to another that all faces have.

This actress was used twice, with straight makeup and with prosthetic aging, for the Rejuvenation photograph in the Multiple Exposure entry.

Prosthetic makeup opens a whole world of special effects to the photographer who wants to go beyond the bounds imposed by reality. However, like any other special effects technique, it has its limits. One is the cost. Good results with prosthetics require good people, and such specialized talent does not come cheap. It is not unusual for the bill for a relatively complex prosthetic session to be the most expensive item in the budget for the photograph. Furthermore, everyone involved

PRODUCTION SUMMARY

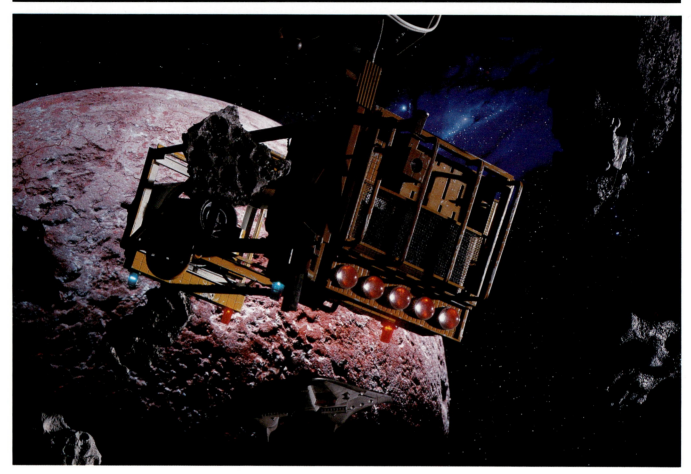

Asteroid Mining

This photograph was shot as a preliminary test of props for use in a science fiction film. The mining utility vehicle in the foreground was assembled from stock plastic and metal materials available from hardware stores and hobby shops. The background cruiser was sculpted from fiberglass. The planet and asteroids were sculpted from styrofoam, and the star and nebula background was airbrushed canvas.

The planet, suspended in front of the star and nebula background, was photographed first to produce a transparency to combine with the rest of the scene by in-camera masking. Once these preparations were complete, three exposures produced the final transparency.

Exposure 1: The cruiser is supported by a rod from the rear. The utility vehicle and the asteroids near the edge of the scene are supported by clamps just outside the cropped image. The asteroids in the center of the frame are supported by monofilament line. The high contrast light (realistic in a space photograph) is easy to gobo to keep illumination off the monofilament lines. The illumination is kept off the background so that it photographs as black.

Exposure 2: With diffusion on the lens, only the miniature lights on the utility vehicle are illuminated to produce a slight glow around them.

Exposure 3: With the foreground unlit, the background is lit to photograph as white. The background transparency is then added to scene by in-camera masking.

Copyright Bill Dempsey, 1991

has to invest some time. The example shown in Figure 21 took more than two hours to produce. The actors and the waiting photographers and assistants need to be paid for their time. Clients do not like these additional costs unless there is a very convincing need for the prosthetic work.

One final caveat is in order. Regardless of how good the prosthetic artist is, his or her skills will not compensate for the wrong actor. As Frank Rogers so succinctly put it, "we can only work with what God and Central Casting send us."

MINIATURE MODELS

Scale models are often expensive and time consuming to build, but they are one of the most effective special effects tools available. A well-made model can make a seemingly impossible photograph easy. Models can let our imaginations run wild. After all, how else can we make pictures of dragons, twenty-first century spacecraft, and the like?

Good model building is an art and a craft requiring much experience. Fortunately, many of us have already begun the preliminary steps toward mastery. Remember the model cars and planes we built from kits when we were children? That is how most expert model makers began their training.

If you want to learn this skill, resume practice where you left off. Build a plastic kit, and plan an experimental photograph around it. If the shot looks good, make a few custom parts to modify your next kit. You may eventually be able to build whatever you want from scratch.

With the preceding in mind, we offer the following sampler of a master model builder at work. Photographer Bill Dempsey has been making top-grade models for his own use and for others use in motion pictures and still photography since he was a teenager. His repertoire of model building techniques is vast. We cannot hope to cover all of his techniques in these few pages, but this is a good introduction. To learn more, experiment and look at periodicals specifically dedicated to this field.

Working Out the Plans

If Bill is designing the model himself, he likes to start out on paper. The first thing he does is to make a series of drawings. This helps him to fine tune his vision of what the final model will look like. He says it also helps him to spot any potential problems early, which saves time and money later.

The next step involves translating the paper drawings to a simple clay prototype that approximates the shape and form of the finished product. As our model maker likes to stress, it is a big jump conceptually from two dimensions to three. Sometimes what looks good on paper simply will not work as a three-dimensional model. That usually becomes only too obvious during the course of putting together the preliminary, or sketch, model.

Building the Clay "Positive"

If all has gone well up to this point, the next step for our model maker is to work out his final plans in detail to scale and size on paper. Once this is done, he inks them on a sheet of Plexiglass™. This is done to provide a base or foundation upon which to construct a full-scale clay "positive" of the model.

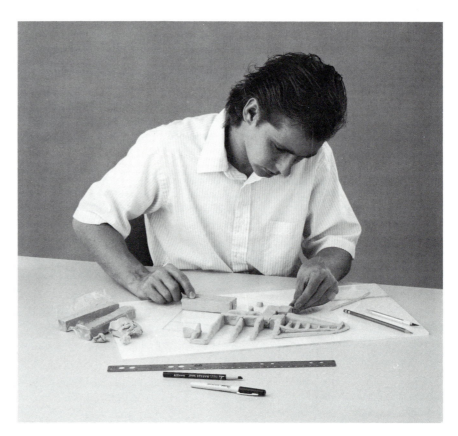

Figure 22 An outline of the plan, inked on a plastic sheet, guides the construction of the clay model of the space cruiser used in the Asteroid Mining photograph.

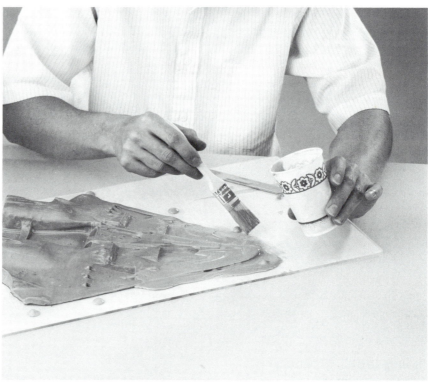

Figure 23 Covering the clay model with fiberglass. When the fiberglass hardens, it will become the mold for the final model.

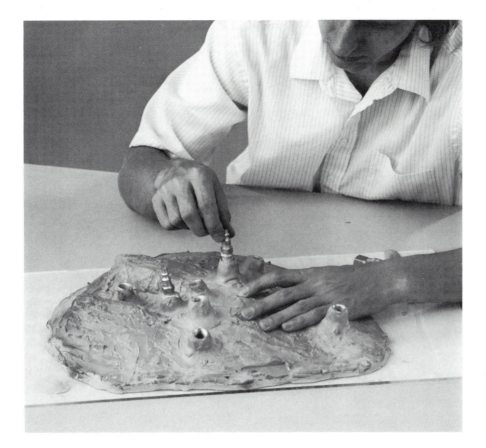

Figure 24 Anticipating difficulty in getting the final model out of the mold, the model builder builds air fittings into the mold. Later, air pressure will gently force the model from the mold.

Because Bill will cast his model in two parts, a top and a bottom, he does this step twice. He completes a clay positive of one side and then the other. These two parts are then used to make the molds in which fiberglass can be cast.

Making the Fiberglass Mold

Now that the clay positive is complete, the next step is to fashion the mold that will be used to cast the actual model. Our model builder thoroughly covers the clay positive and the Plexiglas™ on which it rests with a separating compound, then builds the mold by adding several coats of fiberglass auto body putty, or filler. This material captures the detail of his clay positive well and, properly handled, separates well from the clay and the Plexiglas™. It has the added advantages of being durable, readily available, and relatively inexpensive.

All but the simplest molds need several air hose fittings built into them. Getting a casting to break free from a mold without damage is always a tricky business. If the mold is complex, the risk to the casting is extremely high. Air pressure gently forces the casting free with uniform pressure from inside the mold. The chance of breakage is greatly reduced.

When his fiberglass mold has thoroughly dried, Bill gently pries it loose from the clay positive and carefully removes any clay that has adhered to the interior. Once he has made molds of the positives for both sides of his model, it is time to cast the final model in fiberglass.

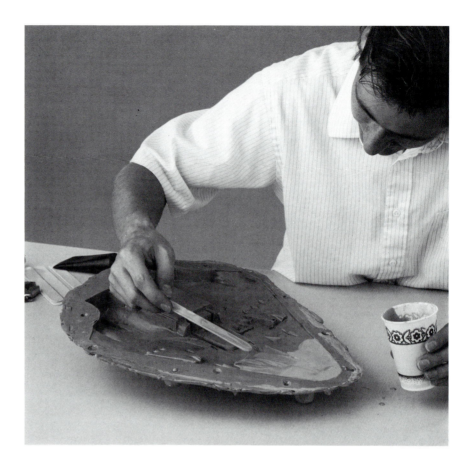

Figure 25 After coating the mold with a releasing compound, the builder fills the mold with fiberglass. When the fiberglass hardens, it will become the finished model.

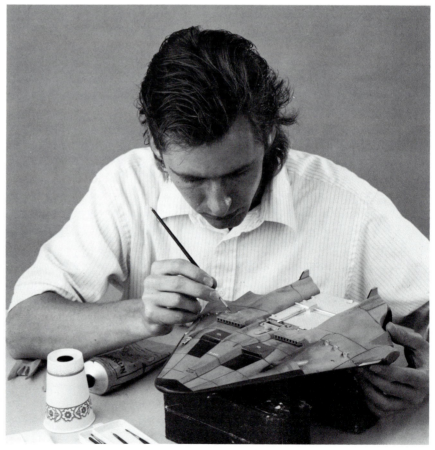

Figure 26 Adding small parts, polishing, and painting completes the spacecraft.

Casting the Fiberglass Model

The fiberglass material used for the finished model is the same material used to make the molds. A coat of releasing compound in the mold prevents the fiberglass positive from bonding to the mold.

As soon as the fiberglass in the mold has cured, Bill gently works the casting out of its mold, constantly forcing compressed air through the fittings.

Detailing the Model

Once the two model halves have been freed from their molds, they can be joined together and the final details completed. This includes adding small parts, etching detail into the surface with a sharp instrument, and polishing away any rough spots. When the surface detail is complete, the maker finishes the model with a painstaking paint job.

MINIATURE SETS

Sometimes less is definitely more. A case in point is the use of miniature sets to produce an illusion. The suntan cream on the diving board in Figure 27 is an effective example.

Photographer and designer Steve Biver wanted an original, eye-catching picture that would emphasize the bright and sunny outdoor mood in a setting obviously appropriate to the product. At the same time, he wanted to show the product as large as possible in comparison to the rest of the scene. Keeping the product large while showing a large scene is not always easy.

The creative solution was to dramatically reverse the relative scales of the parts of the image: make the product, the normally small tube of suntan cream, very large and the pool and diving board very small in relation to it. The idea sounds good, but how do you execute it? Shoot the product and the pool separately, assemble them in the lab, then airbrush an appropriate shadow under the

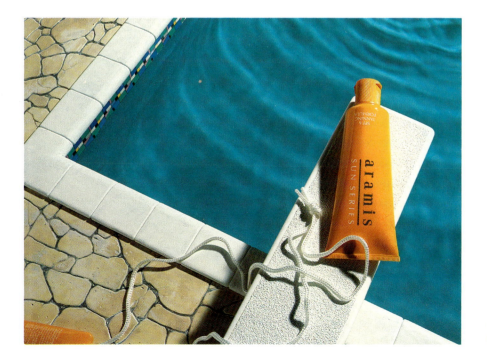

Figure 27 A gigantic tube of cream? Copyright Steve Biver, 1991.

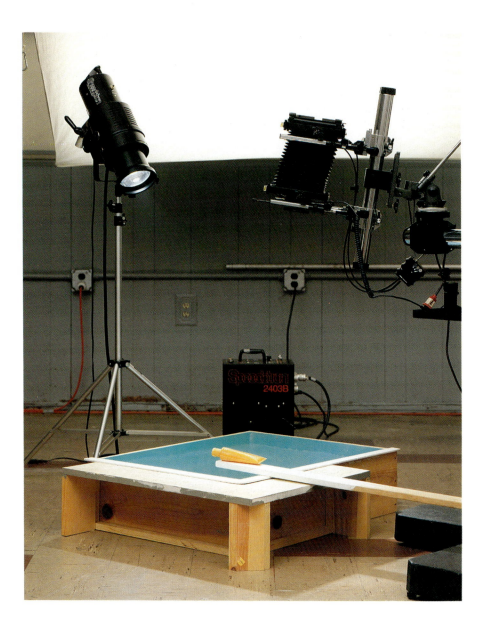

Figure 28 The miniature set in use.

product? Build a huge artificial suntan cream tube to use as a prop and carry it to a real pool?

Both of these were at least theoretically possible, except that all of the outdoor pools were closed for the winter. Using a real pool would have required flying to a warmer climate or artificially mimicking sunlight at an indoor pool. Time, expense, and the quality of the lighting dictated that the easiest solution was a miniature. The photographer recruited set builder Matt McMullen to construct a miniature pool, diving board, and pool-side area.

Figure 28 shows the miniature set in use. Although it was built by a professional model builder, many photographers with good building skills could easily make a similar one. The miniature set made the photography quite straightforward. The only really tricky part was producing realistic waves. Water cannot be miniaturized. Whenever a miniature set uses water, we have the problem of making a small body of water behave like a large one. This requires experimenting. An

agitation method that looks good in one picture may not work in another. The photographer solved this problem by ruffling the surface of the water with a burst of canned "air" of the sort used to clean negatives.

PAINTED BACKGROUNDS

Some of the earliest "special effects" photographs were portraits with the subject against a painted backdrop. As **Figure 29** shows, the technique is still useful today. In this case, the photographer chose a somewhat abstract woodland background to enhance the musician's portrait. He might just as well have used a scene of outer space, geometric shapes, or random color. The advantage of a painted background is that anything is possible with enough artistic talent. The background we want is the background we get.

Most painted backdrops are done on either canvas or muslin. Canvas is heavier and more durable and is usually used for scenic backgrounds. Muslin, on the other hand, is lighter and less stiff than canvas. This makes it easier to drape around a set, to handle, and to carry around.

Muslin is frequently used for nonscenic backgrounds, such as those used to provide a colored, seamless fabric background for a subject. Backgrounds painted on muslin can often be safely folded and stored in a protective bag. Those painted on the heavier canvas must usually be rolled around a core, such as a wood dowel or a heavy-duty cardboard tube.

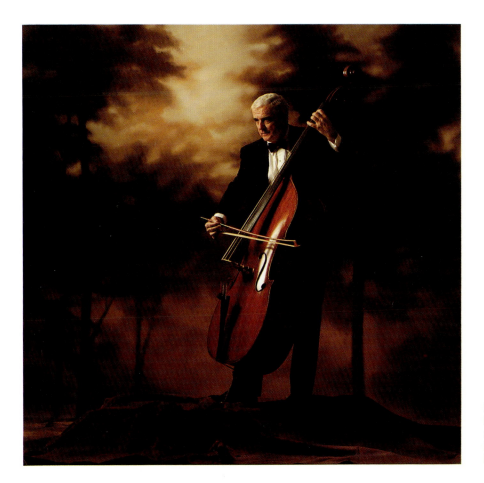

Figure 29 A scene with a painted background may be realistic, abstract, or, like this one, a compromise between the two. Copyright Steve Biver, 1991.

Canvas and muslin are usually available from art supply houses in widths of 8, 10, and 12 feet. Both can be bought in any length. Full-sided, seamless backgrounds, those a model can stand on, are usually about 15 or so feet long and from 8 to 10 feet wide.

Experienced background painters use a wide range of techniques and tools—including brushes, sponges, spatulas, and airbrushes—to apply their paint. The most trouble-free paints are matte-finish, water-based acrylics. Not only do these adhere to textiles well, the dull, matte finish they produce keeps problems with unwanted reflections to a minimum. Because canvas has a fairly rough surface, artists sometimes prefer to seal it with a white gesso, or seal coat, before they paint on it.

Painted backgrounds can be held in place in any convenient way. We frequently use spring clamps to suspend them from a sturdy pole between two background stands. If the background is scenic, the support poll needs to be rigid enough to hold it absolutely flat. If the background is to appear draped, we can support it almost any way.

One of the few problems with painted backgrounds is that normally they do not emit light. If the scene is realistic and contains a sky or sun, we have to spotlight those areas that would be brighter in nature. Failure to do this is one of the most common deficiencies in photographs using painted backgrounds.

Painted Foregrounds

In a closely related technique, we can also paint part of the scene in the foreground on glass. The glass has the scene painted on its perimeter with a clear area in the center for the camera to see through. If the subject is in a set that matches the painting well, the scenes merge and appear to be one.

This technique is more commonly used in motion pictures, where it is called *glass painting*. It is more practical there because the normally smaller image size allows greater depth of field and maintains adequate focus on the foreground scene. Nevertheless, it is also practical in still photography, especially when the execution of the foreground scene is inexpert and needs soft focus to camouflage the defects or when the foreground scene is too abstract for sharpness to be important.

Notice that *foreground* simply describes where the glass is physically located in the set. Painting on the glass above the principal subject may appear to the viewer to be background. In still photography, the only part of the scene that we almost never can produce with glass painting is the part that appears to be the same distance from the camera as the principal subject. The difference in sharpness of the painted scene and the central one usually reveals the difference in their distance from the camera.

FORCED PERSPECTIVE

Forced perspective means adjusting the size of the subject in some part of the scene to create the illusion that part of the scene is either closer or farther from the viewer than it really is.

In practice, forced perspective uses either of two basic techniques. The simplest is to place any large subject far from the camera (or a small one close to the camera), so that it appears to be larger or smaller than in reality. More elaborate

Figure 30 The walls and floor of this miniature set are not square. The perspective is built into them. Copyright Steve Biver, 1991.

forced perspective requires specially made props or sets with fake perspective built into them.

Forcing Perspective by Subject Position

An elephant can appear to stand in a child's hand. If the hand is close enough to the camera and the elephant is far enough away, careful composition can make the illusion nearly believable.

Apparent subject size, however, is not the only visual clue to depth in a scene. Other clues, often subtle ones, give away the trick. For this reason, this type of forced perspective is more often used for a visual joke than for a convincing effect. Still, with attention to those other clues, the effect may be convincing enough for all but sophisticated audiences. One children's film effectively photographed middle-aged actors in forced perspective as elves throughout the motion picture. Photographers see through the effect, but the children cannot.

Successfully forcing perspective by manipulating subject distances requires as much depth of field as possible. Otherwise, the difference in sharpness of the subjects reveals the difference in distance. In addition to using an aperture as small as practical lighting allows, we may use a smaller camera with a smaller image size than quality requirements might otherwise dictate.

Remember, too, that perspective distorts the apparent size of parts of a single subject, as well as the size relationship of subjects to each other. If a foreground subject has more distortion than a distant one, this also reveals that they are not both at the same distance from the camera. We can minimize this problem by positioning both subjects as far from the camera as feasible and using a correspondingly longer lens to get a reasonable image size. Reducing the perspective distortion in both subjects makes the difference in their perspective less noticeable.

At first reading, the need to maximize depth of field seems to contradict using a longer focal length lens because longer lenses have less depth of field. But notice that when we use the longer lens we also move the camera farther away, and thus the subject remains the same size. The more distant viewpoint increases depth of field as much as the longer lens decreases it. Together the two produce no net loss or gain in depth of field.

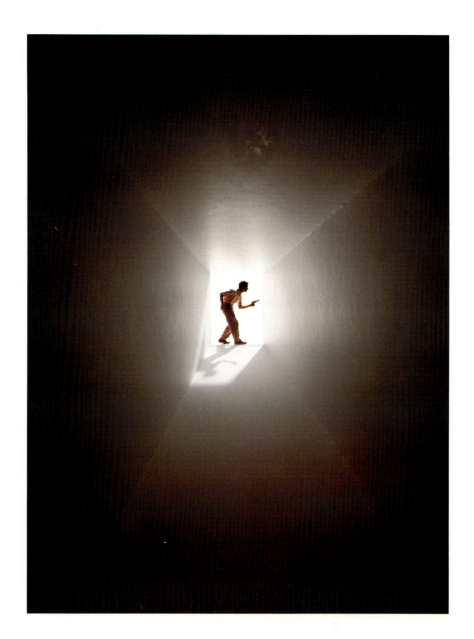

Figure 31 Lurking gunman.

Forcing Perspective with Special Props and Sets

If a single subject extends from the foreground to the background, the only way to force its perspective is to build it with an artificial perspective distortion. The tunnel in **Figure 31** could have been built with parallel walls, and the distortion could have been duplicated with the proper camera viewpoint. However, building this simple prop with forced perspective is as easy as building it straight, and the forced perspective allows greater freedom in camera placement and lighting. In such cases, using forced perspective is simpler than not using it.

Building forced perspective into more complex props and sets is much more demanding. The detail in the ground must get smaller near the back of the set to simulate greater distance. Not only must the model maker have excellent mechanical skills, he or she must also have a good eye for the way photography records detail. Any model maker knows that minute foreground detail makes a prop or set more realistic. Without experience in photography, the same model maker is unlikely to realize that too much background detail in a forced perspective prop makes it *less* realistic. To appear more distant, detail must be rendered more crudely as the camera might record that detail if it really were farther away.

Remember, too, that in a scene on Earth, distant subjects also have less color saturation because of atmospheric haze. Unless a set is intended to represent an airless planet, the model maker needs to use a gradually grayer and bluer paint mixture to color the farther parts of the scene. Forgetting this is one of the most

Figure 32 The tunnel is illustration board; the gunman is a 4 x 5 inch transparency taped to the tunnel.

common reasons for lack of realism in forced perspective sets. If the model maker overlooks this need there are several steps that the photographer can take to produce the desired realism. One is to add a small amount of chemical fog to the scene. Cigarette smoke can also be useful in such situations. It is appropriately blue in color and easy to disperse. Viewing the distant parts of the scene through very thin gauze, dyed a light blue-gray, also produces the desired reduction in color saturation.

Designing Complex Rectilinear Sets

Converging straight lines make perspective more apparent in a rectilinear subject. This makes forced perspective in models like the tunnel very convincing, but it also makes perspective error more obvious. The same visual clues that strengthen the sense of depth also show any mistakes in perspective.

Good draftspeople can draw plans for a forced perspective model with accurate distortion of doors, windows, and other detail, but this is no help if we cannot tell them how much to force the perspective before the drawing is begun. And it is hard to be sure of this until we see the model in front of the camera. Calculations can get the geometry right, but realism involves too many psychological factors to depend on mathematics alone.

With or without the help of a draftsperson, most forced perspective models of rectilinear subjects need to begin with a rough foamcore and gaffer tape mockup in the studio. Determine the basic shapes by trial and error, viewing through the same size camera with the same focal length lens intended for the finished picture. Then, if possible, loan the model maker the camera to check the work on the finished model as it progresses.

PAPER DOLLS

A paper doll is a special miniature consisting of a photographic print of a larger subject. We usually use paper dolls to create a subject that is out of scale with the rest of the scene. The technique is fast and inexpensive compared to photocomposing the picture with masking techniques, and when done carefully it does not necessarily yield inferior results. Used with care, a paper doll is indistinguishable from reality.

The man fighting the dragon is a paper doll about 12 centimeters high. Using a live actor in the scene would have required a much larger set, including a model dragon taller than the studio ceiling allowed. The paper doll allowed us to build the whole scene as a table-top set.

Paper doll miniatures are successful if we keep the viewer from seeing hints that give away the trick. Here are the most important precautions:

1. Mount and cut the paper doll meticulously. Glue the print to a thin but rigid card, and cut with a new blade. Blacken the edges of the card with ink. Then burnish the edges with as much force as is safe to make them as thin and invisible as possible.

2. Center the paper doll in front of the camera lens. This further conceals the telltale edges. If you do not want the subject in the center of the composition, use a view camera. Center the camera on the paper doll, then recompose by moving the rear standard.

PRODUCTION SUMMARY

Dragon Slayer

The hero was photographed in advance, printed from a negative, mounted on a thin card, and cut out to produce a paper doll. The glow around the sword would not be produced until later, but care with the direction and color of the lighting of the man ensured that he would appear to be lit by the glow.

The dragon was made from latex molded on a wire frame. The background was a rear projection, and the foreground rocks were sculpted from styrofoam. The wisps of smoke were puffed into the scene by a cigarette smoker just prior to exposure. Exe-cution involved three exposures.

Exposure 1: With the rest of the scene dark and with diffusion on the lens, a small wedge-shaped light box between the sword and the dragon wing adds the glow around the sword. Then the light box is removed from the scene.

Exposure 2: In the main exposure, a spot of golden light on the dragon simulates lighting by the glowing sword. A sheet of clear plastic with a small hole in it is used in front of the lens to slightly diffuse everything except the paper doll so that the detail in the three-dimensional objects will not exceed that in the photographic print of the man. The translucent white projection screen behind the scene is covered with black velvet during this exposure.

Exposure 3: The projection screen background is uncovered and, with all other lights still off, the projector is turned on to add the cavern background.

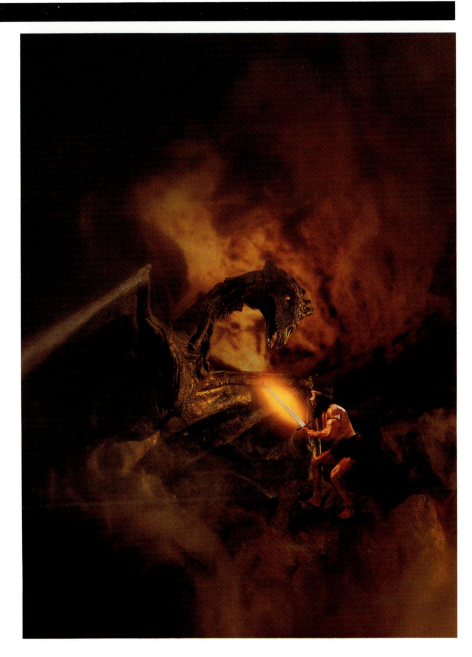

3. Beware of the difference in sharpness between the paper doll and the rest of the scene. No photographic print is as sharp as its subject. The difference in visible in a paper doll and a real subject can be apparent when they are side by side.

As a rule of thumb, scale the scene so that the paper doll is about twice the height at which it will reproduce in the finished picture. This will stand up to inspection of a picture reproduced at an average magazine page size. Smaller paper dolls will work for smaller reproductions.

An alternative to using a large paper doll is to diffuse the scene to camouflage the lack of sharpness. The dragon picture uses a light diffusion filter in front of the lens, with a hole corresponding to the location of the paper doll. Slightly diffusing everything *except* the paper doll keeps the sharpness of the elements in the scene similar enough to maintain the illusion in even a large print of this photograph.

4. Camouflage the area where the paper doll physically touches the set, or retouch the shadows in the final picture. A two-dimensional cutout will rarely cast

Figure 33 The ice is plastic. The water is real, but it too could have been plastic.

the same shadow as a three-dimensional one. The dark ground and the position of the rock eliminate the need for retouching the dragon picture.

5. Use light and color to blend the elements. True of any picture using elements that originated in different scenes, this rule is even more essential when we try to make a paper doll look three-dimensional. The lighting of both the man and the dragon was planned to make the glowing sword appear to illuminate both.

COMMERCIALLY MANUFACTURED PROPS

There are a few specialized props that photographers have asked prop makers to build so many times that they are now manufactured commercially. Prop makers in cities with major photographic industries build certain props whether or not they have a current order, keep them in stock, and sell them off the shelf whenever anyone needs them. The increased volume of production makes these props affordable to photographers who do not have the budget to commission specially built props.

Readily available and reasonably priced, such acrylic and glass props as the "pour" (the fluid coming out of the bottle and pouring into the glass) and the "splash" (the splash of it when it hits and swirls around the bottom of the glass), along with a wide variety of differently sized and shaped ice cubes, snow, icicles, spills, drips, droplets, bubbles, and the like, are typical of the kinds of props the better special effects houses offer. Their judicious use can save the many hours of hard work and countless sheets of ruined film that are bound to result from trying to use the real thing.

In addition, these suppliers often offer an assortment of very useful special effects chemicals. These include such compounds as those that produce bogus crushed ice, frost effects, and steam when added to water (a lifesaver when you are trying to shoot a cup of coffee that really looks steaming hot). Other similarly useful products include specialized adhesives, dulling sprays, polishes, and fluid thickeners that will help you to produce your own good-looking spills and drops.

We would like to recommend some of these prop makers because they are very good and deserve the endorsement, but we do not know who will be the best in the business in whatever year you read this book. We do encourage you to shop the advertising in photographic periodicals and buy an ice cube or two. If their props look good, call them up whenever you need to talk about customized versions of their specialties. Some of them can color match a solid splash to the liquid you need or shape the splash to approximate the composition in the art director's layout!

CHAPTER 3

IN-CAMERA EFFECTS

Like the previous group of physical effects, the techniques in this chapter also occur in front of the camera. However, the tools included in this group differ from those in the previous section in that they create a scene that is different from the one that a viewer in the camera's position might see. This disparity in what a viewer and a camera sees is due to the differences between human and photographic vision.

In-camera effects usually depend on two factors: (1) the ability of films to accept repeated exposure and (2) the one-eyed perspective through which a camera views the world and the resulting lack of depth perception.

MULTIPLE EXPOSURE

Multiple exposure is the single most common special effects technique. It is also the oldest. From the earliest days of photography, photographers were startling their viewers with proof of ghosts, portraits of twins who had never been born, and scenes of the deeds of mythical gods.

In the broadest sense, the majority of special effects techniques involve multiple exposure. We often use multiple exposure in combination with another technique. In-camera masking is an example of a technique for which multiple exposure is essential. In other effects multiple exposure is not completely necessary, but it is almost always the most convenient procedure. An example of this is simulating the movement of a static subject: one exposure of the still subject, plus another with movement to add a blur.

We can simplify the discussion of multiple exposure by immediately excluding any processes that use precise subject masking. Although such techniques do use several exposures on a single piece of film, the whole purpose of masking is to keep each area in the composite image from getting more than one exposure. The film responds to each exposure as if that exposure were the only one. Technical problems associated with unmasked multiple exposures are completely eliminated.

True multiple exposure means that at least part of the film surface is exposed by more than one image. The time and cost savings are apparent: foregoing a set of masks allows you to produce the effect in a single work session. Subsequent steps to combine the images are unnecessary.

However, we do not usually use multiple exposure just to save money. Transparent subjects and soft-edged subjects are often more believable when we use unmasked multiple exposures to combine them with other subjects. Glass, flame, glows, and blurs appear real only when the background is visible through them. Such apparent transparency is a natural consequence of multiple exposure.

PRODUCTION SUMMARY

Light—Science & Magic

This is the cover of the authors' photographic lighting textbook. The transparency of the glass strobe flash tubes makes them an appropriate subject for multiple exposure. The image of the sun was furnished by NASA as a transparency, and the glowing gases in the foreground are a piece of tracing paper, which was sprayed with black paint to produce dark areas and lit from the rear by gelled lights to produce color in the white areas. The image required three exposures.

Exposure 1: The strobe flash tubes are lit conventionally but with an orange gel on one of the lights to relate the color on the glass to the rest of the scene.

Exposure 2: The film is re-exposed by another camera to record the foreground gases.

Exposure 3: The transparency of the sun, placed on a light table, is photographed on the same film by another camera. Clear glass in front of the lens is smeared with a ring of clear grease to diffuse the edge of the sun enough to make it resemble the foreground gases.

Achieving the same effect with masked images is possible by only the most skilled lab technicians.

The apparent transparency of the subject is also the chief disadvantage of multiple exposure. In extreme cases the subject is so transparent that it is no longer even visible in the scene! Good multiple exposure technique consists entirely of controlling the gray scale value of one subject exposed over another one.

Mastery of the technique produces an image of the subject that is as transparent or as opaque as it needs to be to appear real. That mastery also allows anticipating when multiple exposure will not produce a successful picture, when to rethink the scene to make multiple exposure more feasible, and when to shoot the images separately and combine them in the lab with masking techniques.

The Relationship of the Subject to the Background

The distinction between a subject and a background is arbitrary. If we superimpose an aircraft model over a cloud painting, the clouds could be considered to be a background or a secondary subject. For this discussion, we will consider a background to be a reasonably uniform tone without detail. This means that a cloud painting is a secondary subject, not a background, because it has detail.

Successful multiple exposure requires predicting the gray scale value of one tone added to another. We can more easily talk about adding these exposures together if we assume the background is a single tone instead of a whole range of tones. Later we will examine what happens when we superimpose a subject over the range of tones in a secondary subject.

Using a Black Background

The easiest multiple exposures are of white subjects against black backgrounds. *Black* means "no light," and with no light there can be no exposure. In practice, black backgrounds do expose the film but so minimally we can usually ignore it. When we re-expose the film, we compose the scene so that the new subject is in the black area surrounding the first one. The cumulative exposure of the film by the new subject and the slight exposure by the black background appear identical to a single exposure of that subject alone.

Black backgrounds allow equally good multiple exposures in a camera loaded with either negative or reversal material. We can also shoot the subjects on separate pieces of film and do the multiple exposure in the lab, but this way *requires* reversal materials. Clear background areas in a negative fully expose photographic paper. Subsequent exposures in that area on the print have little effect. On the other hand, black background areas in a transparency allow almost no light to pass through. Those areas on a piece of reversal paper can then accept subsequent exposures.

If other requirements of the shot demand that separate negatives be combined in the lab, consider sandwiching them and printing them all at once instead of using multiple exposure.

The ease of multiple exposures on a black background is itself an argument against this kind of picture. We have no masochistic desire to make a task unnecessarily difficult, but we do insist that special effects be believable. So many photographers have used so many black backgrounds for so many multiple exposures that viewers instantly respond, "Aha! Multiple exposure!" Even if that response is unconscious, it probably harms realism. This does not mean we should never make such a photograph. We intend to do more of them, and you probably will too. It does mean that we should consider alternatives before proceeding with the easiest solution.

Keeping the Background Black

Few black backgrounds are perfectly black. The slight exposure they produce on film is undetectable in a conventional photograph, but the effect accumulates with multiple exposures. A large enough number of repeated exposures causes the film to appear as if it had been fogged by careless processing. The number of times the film can be exposed without visible degradation depends on how closely a dark background approximates absolute black.

Any black paper background that appears black in a single exposure may be too light to remain black with additional exposures. Consider replacing the paper with black velvet. Keep the background as far as possible from the subject so that less of the subject lighting reaches the background. You may also want to drape any light colored parts of the set in black velvet to further reduce light spill. The use of gobos, even if they are not needed for any other reason, can also help to keep light off the background.

Still another way of producing a very black background is to use glossy black material and then to use polarizing filters on both the lights and the camera lens. This use of polarizers almost completely eliminates all reflection from the background. This method also affects the highlights on the subject and is, therefore, not appropriate to some subjects.

Remember, also, that some of the light that in the image appears to come from the background is actually flare. Light reflecting inside the lens and inside the camera exposes the film identically to light reflecting from the background and can accumulate similarly with multiple exposure. The remedy is to shade the lens more carefully than conventional images require.

The most difficult black background is one that is not visually black at all. We often use white translucent paper or plastic that is illuminated during one exposure then kept dark for another. Even two exposures of such a "black" can sometimes degrade the image. Be sure this type of background has as little extraneous light as possible. Consider covering it with black velvet during the unilluminated exposures.

Using Colored or Gray Backgrounds

Light-colored subjects often superimpose well on dark, but not black, backgrounds if only one exposure is added to the primary one. The background color always contaminates the subject color. The degree of contamination depends on the specific colors of the subject and the background. The contamination seldom harms an image of a transparent subject because the color contamination is similar to what it might be if the subject were really on a colored background. Even with subjects that need to be opaque, the contamination is surprisingly unapparent with some color combinations.

The only way to be certain of the effect of combining colors through multiple exposure is to test them on the same film to be used for the final photograph. However, there are a few principles that allow us to roughly predict which combinations are most likely to work.

As a rule, colored backgrounds cause less trouble if they are pure colors (a mix of only a narrow range of wavelengths of light) *and* if the subject color is a mixture of light wavelengths that includes the background color. Thus, white subjects work with most backgrounds. White is a mixture of colors that includes, by definition, all visible colors, including the background color.

Not only is yellow a visually light color, but most yellow pigments and dyes also contain a significant amount of red and green. Therefore, we can sometimes expose a bright yellow subject over a red or green background almost as well as over a black one. The same yellow, however, cannot be used with a blue background. Because blue and yellow are complements, there cannot be much blue in a yellow pigment. The contamination of a yellow subject by exposing it over a blue background is always apparent.

PRODUCTION SUMMARY

International Satellite Communications

This photograph was used for a communications company's trade show exhibit. The plastic globe was 6 inches in diameter. The communications devices inside the globe were bought at repair shops and spray painted white. The satellite is an artist's rendering. Four exposures combined the elements in a single transparency.

Exposure 1: The plastic globe is photographed on the flags. The background is translucent plastic lit from the rear by two gelled lights.

Exposure 2: Moving the film to a second camera on a second set, the communications devices are photographed through a crystal ball bought from a magicians' supply store. This distorts the objects as if they were actually in the transparent world globe. A black card with a circular hole is, placed just in front of the crystal ball and prevents the camera from seeing anything except the scene through the ball.

Exposure 3: The film is given another exposure by copying a transparency of the satellite on a light table. The back of the view camera is shifted during the exposure to simulate movement.

Exposure 4: Film is re-exposed in another camera to a pinhole star field of black paper on a light table.

Unfortunately, whatever we do to avoid contamination of the subject color by the background applies only to the subject highlights. If the subject shadows are black, the background color is clearly visible in them, for the same reason that any color records visibly over a black background. If the subject shadows are not black, the color contamination is less, but it is still more visible than in the highlights. Keeping the appearance of the subject opaque requires lighting it with as little shadow as possible. If other lighting considerations demand shadows in the subject and if the subject must not appear transparent, then we have to use a black background or combine the subjects with masking instead of multiple exposure.

A gray background is a special case of colored background. It does not hurt the subject color, but it does degrade the gray scale reproduction of the subject. Because the gray background flattens the subject gray scale, we are tempted to light the subject with as much contrast as possible so that the flattened composite exposure resembles normal subject contrast. Sometimes this is a mistake.

The best lighting strategy for a subject superimposed on a gray background depends on the subject. Like a colored background, a gray background affects the shadows in the subject more than its highlights. If high contrast lighting of the subject produces small dark shadows, viewers will not notice a certain amount of background fog added to those shadows, and the resulting contrast may appear normal.

However, if the lighting produces large dark areas in the subject, the very size of those areas makes the defect more apparent. In those cases, lighting the subject more uniformly minimizes the visible tonal degradation. Even though uniform subject lighting means less contrast, keeping the subject tones light puts those tones on the part of the gray scale least affected by additional exposure. So the contrast of the subject is altered less.

Using Nonuniform Backgrounds

One good way to use color in the background and minimize contamination of the subject color is to graduate the background tone from black to a color. We then position the subject mostly over the black area.

Keep in mind that white subjects suffer the least contamination by background color and that the shadowed part of any subject suffers the most contamination. The color contamination of a subject superimposed over a graduated background is less visible if we light the subject so that its shadowed part superimposes over the black part of the background. Its highlight area may then superimpose over the colored part of the background with less contamination.

Several lighting techniques can produce a graduated background. We can use a colored background and light only a part of it; we can light part of a white diffusion material from the rear with colored light; or we can light a black background from the front with colored light. These methods and variations on them are good. The best way is the one that works with the subject lighting in a particular scene.

Multiple Exposures of Subjects over Subjects

The image of a subject is a range of light and dark values that make up the detail in that subject. Wherever the background subject is light, the foreground subject will appear transparent. Dark areas in the background subject provide good places to superimpose a foreground subject. In the *Rejuvenation* picture we see almost

PRODUCTION SUMMARY

Rejuvenation

This photograph required four exposures: a dummy head, the actress with prosthetic makeup, the actress without makeup, and the background star field. Because facial expression was important, all exposures were on separate sheets of film so that they could be individually selected. The images were later combined in the lab by exposing a single piece of internegative film to each transparency in sequence.

The techniques we used to ensure that the star back-ground would fit properly are useful for many assignments requiring multiple exposure.

Step 1: The three heads are photographed individually. Careful lighting keeps the film black in the areas where images will be superimposed.

Step 2: One head after another is projected by an enlarger and traced onto a single piece of paper. The resulting final layout guides the photographer in creating the star background and, later, the lab technician in producing the composite internegative.

Step 3: The layout is taped to a light table and retraced on the ground glass of the camera. Had more precise alignment been necessary, the layout could also have been photographed on line film. A film positive made from that line film could have been taped to the camera ground glass, ensuring a perfect match of the two sketches.

Step 4: Black paper is taped to the light table and a small fresnel spot behind the camera projects the ground glass tracing onto the paper. The projected image is retraced on the black paper with a colored pencil. (Be cautious! Projecting the groud glass tracing with a spot light that is too bright will damage the camera and may start a fire!)

Step 5: The black paper tracing is cut into a silhouette of the foreground subject.

Step 6: Another piece of film is exposed several times to a series of star patterns with varying degrees of dif-

fusion and a cross screen filter. The black paper silhouette stays in place for all of these exposures and ensures that no stars will be positioned over the foreground subject.

Laboratory assembly by Washington House Photography, Inc.

PRODUCTION SUMMARY

Data Bridge

This image was created for a brochure about a removable hard disk, that can be used in old and new microcomputers. The type was photographed on a real computer screen so that the pixels would be visible. Preparation of the film with the type preceded the main exposure.

Photographed on 8x10 inch line film, green type on a black screen produced an image with black type on clear film. Several identical sheets of this film were taped together into a long band and hung on two wooden dowels in an inverted arch. This arch was then photographed on another sheet of line film to produce a negative of the curved type.

It was impossible to stretch the arch far enough to obtain adequate perspective distortion and still get good depth of field using the line film. Therefore, the first shot of the type arch, with inadequate distortion, had to be placed on a light table and copied at an angle, using view camera manipulations, to increase the distortion.

Once the type was done, multiple exposures to produce the finished picture were straightforward.

Exposure 1: The computers are conventionally lit.

Exposure 2: The film is re-exposed by the negative of the type arch on a light table backed by a yellow gel.

Exposure 3: Another exposure, very out-of-focus, of two holes in a black card on a light table backed by a magenta gel produces the glow on the part of the type near each screen.

no accidental transparency in the highlight areas of the faces superimposed on the shadow areas of other faces.

Superimposed subjects are most visible when the background subject is big and dark and the foreground subject is small and bright. We can then apply all of the same logic we use to analyze any other subject against a dark background. If a particular combination of exposures makes this impossible and if we do not want the foreground subject to appear transparent, we need to use masking instead of simple multiple exposure. For example, an aircraft model against a painted sky might be a likely candidate for such treatment.

However, maximum visibility is not always ideal because often the primary objective in superimposing two subjects is to blend them enough to create a bit of mystery about what the viewer is seeing. How can we blend subjects enough to create an illusion but ensure that neither subject will be overly camouflaged? The answer to this depends on the specific scene. Here are some suggestions that work for many situations. Following some suggestions tends to exclude others, so no scene is likely to require all of these methods.

Define one subject by its shape and the other by its detail. The subject defined by its shape must have as little texture as possible; the one defined by its detail needs pronounced texture. One classic, clichéd example of this is a nude superimposed on wood grain.

If the subject is defined by its detail, keep the detail small. Large bright and dark areas in one subject break up the other subject into a series of smaller subjects that may not be identifiable. Thus, while the wood grain makes a good texture to superimpose, the United States flag makes a bad one unless we use an exposure or lighting technique to make the stripes of more similar value.

Decide which is the background subject and which is the foreground. Then reduce the exposure on the background subject or increase the exposure on the foreground one. This technique applies all of the logic of keeping the subject visible against simple backgrounds.

We usually determine whether a subject should be background or foreground on the basis of whether it can tolerate overexposure or underexposure rather than on any perceptions of its importance. Using this technique, the United States flag could become a good background subject because even a very dark image of it is readily identifiable.

Use lighting or vignetting to produce large shadow areas in the background subject, then position the foreground subject in that shadow. Careful placement of the highlights and shadows allows normal exposure of both subjects but keeps them from overly interfering with each other.

Using a White Background

Understanding why black backgrounds work well for multiple exposures also explains why multiple exposure in the camera is nearly impossible against white backgrounds. The first exposure fully exposes the film everywhere except the area that the subject occupies. Subsequent exposures have little effect because they record their images in areas where the film is already fully exposed. Furthermore, if subsequent exposures also have white backgrounds, the exposure of those backgrounds obliterates the original subject.

The fact that practical exposures never fully expose the film does not significantly help the problem. This simply enables us to obtain poor results instead of no results.

Figure 34 Using a white background usually precludes multiple exposure in the camera. Instead, this is a sandwich of two transparencies. The same photograph could have been produced in the darkroom by a double exposure of two negatives on one piece of photographic paper.

We can produce good multiple exposures of subjects on white backgrounds, but we have to do them in the lab instead of in the camera. This requires using negative material and shooting each component of the scene on a separate piece of film. The white background records at near maximum density on the negative. Because little light passes through those areas, we can expose photographic paper by a series of negatives, one after another, without accumulating much exposure in the background.

In this method, keeping the white background as bright as possible is as important as keeping a black background as dark as possible. When we make the original exposures, we must light the background as brightly as we can, short of causing too much flare. The brighter the background, the greater the density it produces on the negative. The greater that density is, the more exposures we can make on photographic paper without allowing the accumulated background exposures to fog the composite image.

If we must shoot transparencies instead of negatives, we can combine them as a sandwich, then copy the sandwich. This is a usable alternative to multiple exposure as long as the sandwich does not have enough sheets of film to allow base fog to degrade the result.

GLOWS

A glow is an aura of light that appears to be coming from one of the subjects in the scene. In planning a photograph, we need to distinguish between the glow itself and the effect of the glow on other subjects in the scene. These are usually separate photographic effects. We use one technique to create the aura of light around the subject, and other more conventional lighting techniques to make the other subjects appear to be lit by the glowing one. We may use either or both of these effects. When we use both, each reinforces the apparent reality of the other.

In nature, we rarely see a glow. More often, we see the effect of the glow on other subjects. We know that an incandescent bulb glows because we can see its light on the objects around it. We do not see an aura of light around the bulb itself (unless we view the bulb in a smoky room or through dirty eyeglasses, and these are simply special cases of the effect of the glow on surrounding objects).

Despite the impossibility of a visible glow in clean air, everyone imagines how one would look if it did exist. This mental image is just as powerful as a physical reality, and it tempts artists to try to represent it. The saints' halos in medieval religious paintings and the laser weapons in modern science fiction films are results of these attempts.

What Makes a Glow Realistic?

The rarity of visible glows in nature means we have to engineer the effect on our own with little help or guidance from physics. This makes the photographer entirely responsible for the realism of the effect. Forgetting this can result in an effect as unbelievable as those medieval saints' halos. Whatever the technique, glows need careful execution. Very slight differences in exposure or diffusion can determine realism or the lack of it.

Photographers have no obligation to make a glow realistic, but reality makes a good start for any subsequent manipulations. The following are some of the things we need to think about.

Subject Tonal Degradation

A real glowing subject is difficult to expose. If a light bulb is the sole illumination of a scene, it is impossible to expose the film for good detail in the bulb and in the rest of the scene simultaneously. If we want a subject to appear to glow, we must not give it a highly detailed normal exposure. Overexposure or flashing simulates the exposure problem a real glowing subject would cause.

Subject Lighting

A real glowing subject is shadowless unless it is partly covered by nonglowing parts. However, a subject lit by other sources almost always has some shadows in its image. To make the subject appear illuminated by its own illumination, we must light it with as little shadow as possible. This generally means keeping the main light near the camera so that shadows fall on the back of the subject where the camera cannot see them. Large soft light sources also help because the shadows they produce have no sharp, clearly defined edges to emphasize their presence.

Subject Color

Real glowing subjects approximate the color of the glow. A green subject, for example, cannot produce a red glow. This does not necessarily mean that a subject that appears to glow needs to be lit by light of exactly the same color as the glow.

If the glow is a strong color, we may not want to light the subject identically because strongly colored lighting eliminates any other colors in the subject itself. This does mean, however, that the subject usually needs lighting of at least the same color family as the glow. If the glow is deep red, try a light red gel on the subject lighting.

Diffusion

Real glowing subjects cause lens flare and halation in the film. Extreme sharpness in the subject hinders the illusion that it glows. Diffusion on the camera lens helps the illusion. This is especially effective if the diffusion is used only for the exposure of the glow, then omitted during the principal exposure to keep it sharp.

Superimposing a Glow over the Subject

One of the easiest ways to produce a glow is to simply create the glow as a separate piece of art and re-expose the film, placing the image of the glow over the subject. The glow itself can be any soft-edged shape produced by any handy technique. Airbrushing the glowing shape on clear acetate works well. Another useful way of producing a glow is to airbrush it on glossy black paper, vinyl, or plastic and then photograph it with both the lights and lens polarized. Cutting a hole in a thin black card and photographing it with the camera unfocused is just as effective if precise control of the shape is not necessary. We can place either of these on a light table and illuminate them with white light or colored light.

Close registration of the glow with the subject is not usually important; approximate positioning is adequate. If, however, close registration is important try using a *beam splitter*. This is a partly silvered mirror placed at an angle in front of the lens. The camera sees both the scene through the beam splitter and the scene reflected in it. The result is a perfectly registered composite image of the glow and its associated primary subject.

The subject may be either the original object or a finished transparency of it. If the subject is an object that does not move, keeping it in place and working with it and the glow setup simultaneously allows better control. In a multiple-camera setup, moving Polaroid™ film from one camera to another and re-exposing, with both setups still available, allows fine tuning the subject lighting to be compatible with the appearance of the glow.

In its simplest form, the center of the glow is open, and no attempt is made to mask the subject. This means that the glow itself also flashes the subject, fogging its shadows and overexposing its highlights. This degradation of the image of the subject usually contributes to the illusion, especially if the glow is colored. If the glow is white light or if we do not want the glow to degrade the tones of the subject, a mask for the subject must be sandwiched with the glow, and close registration becomes essential.

Background Glows

Another easy glow requires a spotlight glow on a flat background behind the subject with enough diffusion in the exposure of the subject to cause the glow to appear to wrap around the subject and record some of its light over the image of the subject.

The background may be either an opaque seamless paper with a spotlight directed at it or a translucent sheet with a light behind it. The glow on the trans-

lucent sheet is easier to control, but we have to keep light off the rest of the white sheet outside the boundary of the glow. Subject lighting striking that area can degrade any other parts of the scene we try to add by additional exposures.

This technique always requires two exposures and a static subject. The amount of diffusion needed to diffuse the glow into the subject is almost always too much diffusion for the subject itself. We expose the glow with diffusion on the lens and the subject in darkness. During the second exposure, we remove the diffusion, light the subject, and turn off the light on the background.

The two exposures may be made in either order; the sequence does not affect the result. Variations on this technique may use a small amount of light on the subject during the glow exposure or a small amount of diffusion on the lens during the subject exposure.

Using two exposures, with and without diffusion, is also a good technique to consider whenever the subject really does glow with its own light. Try one exposure with diffusion on the lens and just the light of the subject itself turned on. Then re-expose the subject without diffusion and with any additional light the scene needs. This adds a bit of visible glow around bulbs and candles but without significantly reducing the general sharpness of the photograph.

Making a Background Glow for a Miniature Set

Using a sheet of translucent material for a background is easy to control, but it requires a lot of space. The background must be far enough away to keep the foreground subject light off of it and large enough to fill the image area at that distance. Working at closer distances requires covering the background with black during the subject exposure. Neither of these options is convenient for a subject in a miniature set, especially if the glowing subject has other subjects a few inches behind it.

A special light source, taped together from cardboard, or similar material, can put a glow behind almost any miniature subject. The wedge-shaped box shown in **Figure 36** has a narrow end to insert into the set behind the subject. The other end is large enough to accommodate a standard strobe head. The narrow end of the box has a small window with tracing paper or other translucent material in it. Part of the translucent material is covered with opaque ink or paint to produce the shape of the glow. We mount the strobe head on a boom. Raising the boom easily removes the whole arrangement from the set.

Using this device, it is best to expose the glow before exposing the primary subject because it is easier to take the light source out of the scene than to put it in. Even in very dim light, we can swing the light out of the set without touching anything else. Positioning it, however, is difficult in tight working conditions. If the primary exposure is already recorded, it may not be possible to position the glow without bumping something enough to misregister it. Never leave such a lighting device turned on unattended. Photographers have started fires when the heat from the lamp ignited the surrounding cardboard. Be careful whenever you closely confine any light source and keep adequate fire extinguishers handy.

Controlling the Shape of a Background Glow

We often want the shape of the glow to approximate the outline of the subject. In extreme cases nonrealistic glows may follow the outline of the subject precisely.

Using the translucent background described above, the background glow is easy to shape to fit any nonmoving subject as closely as we please. We will describe

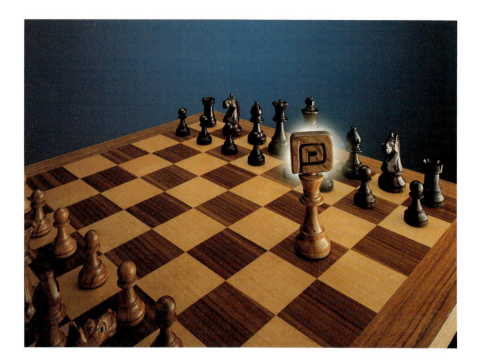

Figure 35 The glow comes from a miniature light box just behind the king. The rest of the scene was dark during that exposure. After the light box was removed, the whole scene was illuminated, and the film was re-exposed. Diffusion would have made the glow more realistic, but it would also have obscured the client's logo too much.

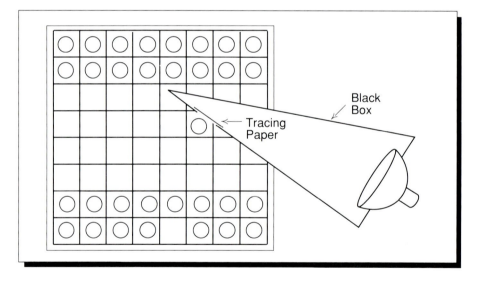

Figure 36 This triangular light box allows a glow to be inserted into a small set. During its use, it is the only light turned on. This was used for the glowing chess king and for the glowing sword in the Dragon picture in the entry on Paper Dolls.

how to make the outline of the glow fit the subject exactly. The same process also works well for a more realistic glow with a looser outline.

1. Position the subject in front of the camera, compose, and focus.

2. Put a translucent white acrylic sheet behind the subject. Tape a black paper background over the Plexiglas.

3. Project a small spotlight through the camera ground glass if you are using a view camera. (*Be careful not to overheat the camera!*) If the projection distance is short, a high intensity flashlight may produce enough light for this purpose and produce much less heat than a photographic light. Alternatively, temporarily replace the camera with a small, high-contrast light source. Either will cast a shadow of the subject on the black background. This shadow perfectly agrees with the subject outline seen from the camera viewpoint.

Figure 37 The glow around the air-brush is a piece of masked translucent plastic behind the airbrush. During that exposure, the principal illumination was turned off. The white plastic background was then covered with black velvet before making the primary exposure. The glows and stars at the tip of the airbrush were rear-illuminated, painted tracing paper and holes in black cards. Their techniques are identical to those used in the Out of Body photograph in the Diffusion entry in Chapter 4.

Figure 38 The airbrush, in darkness, with its background glow uncovered.

4. Cut the black paper along the edge of the shadow. This produces a mask that we can use to shape the glow.

5. Take down the black paper mask and reattach it behind the acrylic sheet. Use the shadow of the subject to reposition the cutout. Light the masked background from the rear. The beam of light passing through the cutout illuminates the translucent sheet with a glow outlining the subject.

The distance to the light behind the background and the distance between the black outline and the translucent sheet both affect the sharpness of the edge of the glow. Putting the light farther away sharpens the glow. Moving the translucent sheet closer to the black cutout also sharpens it. Notice that we can control the size of the glow by changing the distance between the black and translucent sheets, then we can readjust its sharpness by repositioning the light.

Executing this technique with a single exposure is difficult. If the white plastic background is too near the subject, it will be illuminated by the subject lighting. If it is too far from the subject, the shadow of the subject on the black paper will be too dim to trace the mask. Using two exposures allows draping the white plastic background with black velvet during the subject exposure. The glow can then be added in a second exposure, with diffusion if we like, while the subject is dark.

RAYS

A ray of light coming from a subject in the scene can be one of the most spectacular effects. Depending on the other requirements of the picture, however, a ray can also be one of the most difficult effects. It is worth anticipating those difficulties and learning some ways to avoid them.

Fog and Smoke

A ray of light passing through clean air is invisible. The only time the camera can see a ray is when it shines directly into the lens or when there are particles in the air to reflect some of the light from the ray to the camera. To make rays visible, we usually fill the scene with fog or smoke.

Filling the air with fog or smoke presents no additional problems if we want the scene to look foggy or smoky. It is easy to make rays visible if we are free to use a great deal of fog. But if the photograph does not represent a barroom or a battle, the amount of pollution we put into the air becomes a delicate balance. Too much fog becomes visible; too little fails to reveal the ray. Here are some techniques for maximizing the effectiveness of the fog so that the rays become visible but the air still appears clean in the photograph.

Distribute the fog as evenly as possible through the scene

Unevenly distributed atmospheric particles are more visible. Work in an enclosed area with forced-air heating and cooling systems turned off. Produce the fog, then allow the particles to diffuse evenly before making the exposure.

The lack of fresh air makes many types of fog and smoke unpleasant, and some of them can be very dangerous. We strongly recommend using chemicals and equipment from trustworthy manufacturers who have conducted reliable safety tests.

Use high-contrast lighting to produce the ray

An optical spot or a strobe head with a snoot illuminates just the area in the path of the ray. Softer main lights and fill lights can illuminate airborne particles throughout the scene and make the ray indistinct. Remember that reflection from studio walls also provides fill. Working in a large room or a room with black walls produces a more visible ray.

This requirement does not always handicap other lighting considerations. Atmospheric haze softens the ray and scatters enough of its light to provide some fill. Even if the ray is the sole illumination, it will not be as harsh as it would be in clean air.

Compose low-key scenes with dark backgrounds

The darker the scene is, the more apparent the ray becomes. A ray is easily visible with a minimum of atmospheric fog if we see it against a black background.

Against a white background, it will never be visible, regardless of its brightness and of the amount of fog.

When planning the scene, remember that atmospheric haze brightens shadow areas more than it affects the middle tones. Lighting that produces completely black shadow areas in clean air often shows significant detail in those shadows when the air is foggy.

Use two exposures

Atmospheric haze always degrades the image of the principal subject. This is sometimes pleasing, but not always. If the scene is static, we can minimize the degradation by using two exposures. Fog the air, and expose the scene with only the light that produces the visible ray. Then blow the air clean with a fan and re-expose the scene with whatever other lighting is best for the subject.

Using a Paper Screen

If the scene and the subject allow multiple exposure, we can produce a visible ray with no fog or smoke at all. This requires putting a white opaque or translucent screen in the path of the ray while all other lights are turned off.

Figure 39, which shows a red light coming from a computer monitor, illustrated a news magazine article on the health effects of cathode ray tube radiation.

Figure 39 The actor was not present during the exposure that recorded the ray. A white card was moved along the path of light coming from the monitor to record as a streak.

A studio strobe head in the empty monitor case made lighting more convenient. A working monitor could have produced a similar picture but with much longer exposure times. The first exposure was made with the model in position and with conventional techniques.

The model left the scene for the second exposure. We pressed a white card against the face of the monitor and turned on only the modeling light of the strobe in the monitor. When the shutter opened, we slowly moved the card away from the monitor and toward the background. The illuminated card moving along the path of the ray simulated the appearance of the ray itself.

Depending on the composition and the appearance of the ray, the paper screen does not always have to move during the exposure. The red beam passing through the bacterial culture dish in **Figure 40** is an example. This photograph represents a diagnostic device that scans a culture with a laser and then prints out an analysis of what is growing there.

The base exposure for this picture used a background made of a black card with a slit covered with a red gel. The black card had tracing paper a fraction of an inch in front of it to slightly diffuse the image of the slit. A stiff wire rod through a small hole in the background supported the culture dish. Careful lighting illuminated the dish without allowing light to fall on the white tracing paper covering the background.

The result of this exposure was the culture dish with a ray of light below it. An additional exposure of a similar illuminated slit created the top portion of the laser beam, and another exposure added the printout and blue background at the bottom of the scene.

STARS

"Twinkle, twinkle little star. How I wonder what you are?" If you ask that question about a photograph, the answer may involve some simple yet surprisingly effective special effects techniques. **Figure 42** is a typical example.

Star Filters

The star in **Figure 42** was easy to create by covering the camera lens with a star effect filter. Also called *cross screen filters* or simply *star filters*, these are inexpensive and readily available. They are manufactured with different grids engraved on them to produce stars with four, six, or eight rays. Some star filters are variable. They have two separate pieces of optical glass, each engraved with parallel lines. Twisting the two pieces of glass adjusts the angle of the rays emitted from the star.

It is also an easy matter to make star filters by scratching clear acetate with sandpaper. The resulting filter will be acceptable for making a separate exposure. However, the poor optical quality of acetate, degrades the image more than a filter made of optical glass if the entire scene is photographed through it.

The light source for the star may be an electric light bulb or candle in the scene. The results can be just as effective if the light source in the picture is a small highlight, such as that produced by a light reflected on bright chrome or similar metallic finishes, glossy plastic, or highly polished wood. The source in Figure 42 was a small spot reflected from the background just behind the transparent pyramid.

The effect is most visible when the highlight producing the star is small. A

Figure 40 Although the picture represents the scanning of a bacterial culture by a laser, no laser was used here. Instead, slits in rear-illuminated black cards, covered with tracing paper diffusion, produced the effect in two exposures. The printout and the blue background are a third exposure.

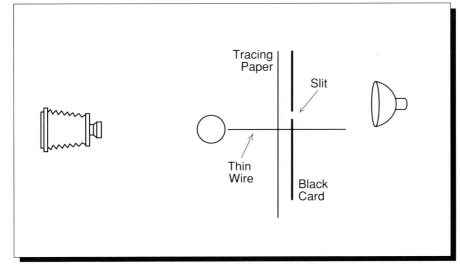

Figure 41 The main exposure for the culture dish, with one part of the laser beam in place.

Figure 42 The concept of "competent cells" is generally comprehensible only to biological researchers and is practically unphotographable. Therefore, the entire purpose of the photograph is to get the readers' attention so they will stop and read the ad copy.

large highlight produces an infinite number of star bursts that obscure one another and produce a meaningless blur.

Stars with a Light Box

For the Medical Data Flow picture, we used pinholes in black paper taped over a light box to create a background filled with hundreds of tiny pinpoints of light. Such backgrounds are easy to produce by either of two basic techniques. One is to build the star field into the original scene, and the other is to add the stars to the image later with a second exposure. The decision between the two usually depends on the subject.

If the subject is a person or anything else that is likely to move, the exact registration needed for a double exposure is nearly impossible, and we put the stars in the original scene. On the other hand, if the subject is stationary, accurate registration is easy, and we can use a double exposure to put the stars in the scene.

PRODUCTION SUMMARY

Medical Data Flow

This picture was used to illustrate gathering many types of medical data into a single database. The cityscape is a cardboard cutout, and the ambulance is a children's toy.

Exposure 1: The computer equipment is in the foreground. Behind it, the cutout cityscape is positioned several feet in front of a black paper background. A light with an orange gel illuminates the background paper just at the horizon.

Exposure 2: The toy ambulance and all the medical paraphernalia except the X ray are laid on a piece of black velvet, and the film is re-exposed to this scene.

Exposure 3: The same scene and camera are used as in the preceding exposure, but during this exposure the view camera front standard is pulled along its monorail to produce the movement.

This exposure is actually several exposures. Because the subjects produce streaks of different bright-ness, the dimmer ones have to be re-exposed. Black velvet covers the brighter subjects during these subsequent exposures of the dimmer ones.

Exposures 4 and 5: The X ray is placed on a light table in the center of a large expanse of black paper,

and the film is given one static and one moving exposure of the X ray, just as we did for the other subjects.

Exposure 6: Another re-exposure is made in another camera to a pinhole star field of black paper on a light table.

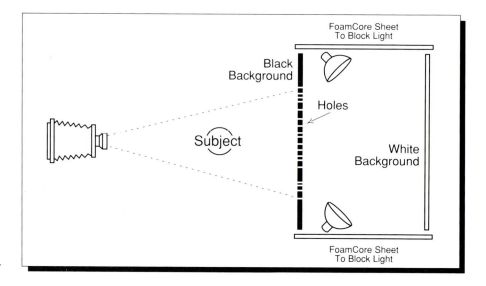

Figure 43 A huge light box can create believable stars behind a standing actor.

Building Stars into the Scene

Figure 43 shows how to add stars when the subject is likely to move. This method produced the stars in the photograph of Merlin with Excalibur discussed in the Hidden Suspension entry.

An oversized light box made of seamless paper and a foam core is held together by gaffer tape, clamps, and light stands. Four strobe heads bouncing from white seamless at the back of the setup provided the large, evenly lit source needed to produce stars of equal illumination.

Making the stars simply required pricking holes in the blue seamless paper at the front of the box with an ice pick. The smaller the stars are, the more realistic they appear, but the more light they need for exposure. Ideally, if enough watt-seconds are available, the white background seen through the pinholes should have enough exposure to produce an adequately large starburst through a very small hole. Practical constraints usually require larger holes than the optimum. Experiment in your studio.

The foam core panels on the left and right of the light box are essential to prevent scattered light from interfering with the lighting of the principal subject, especially since we need the star field illumination to be as bright as possible.

Adding Stars with a Second Exposure

If the subject cannot move, there is no problem in getting the registration precise enough to add the stars with a second exposure. This is the easiest method, because we can use whatever light box is around the studio. Putting together an oversized light box is unnecessary.

We used this method to add the stars to the Rejuvenation picture in the Multiple Exposure entry. (The subject of that multiple exposure was a transparency of a human—not an actual human—so it did not move.) Here are the steps to follow:

1. Expose the subject against a dark background, using a view camera. Trace the outline of the subject on the ground glass.
2. Position the camera in front of a light table covered with black paper.

3. Use a small spot behind the camera to project the ground glass tracing onto the black paper. Punch holes everywhere but inside the outline, or use the outline to cut a mask for use with an existing paper star field.

4. Put the original film back in the camera and re-expose with the stars.

Everyone who tries this leaves a safety margin between the outline of the subject and the nearest stars to avoid superimposing stars over the subject. But too large a safety margin leaves a dark halo, a starless zone around the perimeter of the subject. At least a few of the stars must be very close to the subject to convey the illusion that there are stars behind the subject.

A camera positioned at a close working distance to a small light table will see pinhole stars as defined disks. Use diffusion on the lens, or use two exposures, one with diffusion and one without, for more realistic stars.

Finally, be careful when using a small spot to project the ground glass tracing (Step 3). Photographic lights are hot, and cameras are painted black. The heat buildup can damage the camera or even cause a fire. Pay close attention to the temperature of the camera, and keep the light far enough from the camera to prevent overheating.

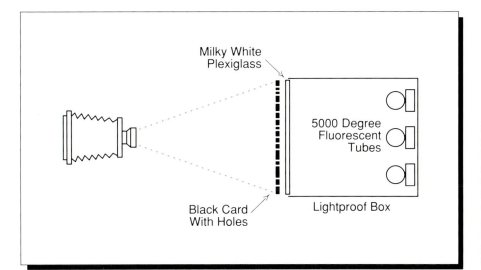

Figure 44 If the subject is not moving, re-exposing the film to a pinhole starfield on a light box is the easiest way to add stars. For stars, the color temperature of the fluorescent tubes is not critical. It is slightly more critical if you want to use the same light box for colored glows. If it is to be used for copying transpar-encies, only the most precisely manu-factured fluorescent tubes—or better a strobe—will do.

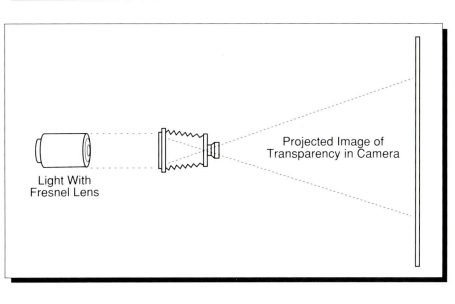

Figure 45 Projecting a grease pencil tracing on the camera ground glass allows easy registration of stars or any other two-dimensional art.

MOVEMENT

One of the obvious qualities of still photography is that subjects in photographs lack movement. This lack probably costs more realism than any other single characteristic of the medium. When a rapidly moving thing is frozen sharply in position, it looks like a photograph of the thing—not the thing itself.

The easiest remedy for this problem is to use a long enough shutter speed to record some of the blur of the movement on film. Unfortunately, the easiest remedy is rarely satisfactory. The result is simply an unsharp picture, and this does not agree with the viewer's idea of reality any more than a perfectly sharp image does.

Humans believe they see moving subjects both ways at once: a sharp image of the subject and a blurred one. (Whether this agrees with the actual physiology and psychology of vision and perception is irrelevant. Satisfying human viewers requires showing them the images they *think* are most real.) If a photograph is to simulate movement convincingly, it too needs to combine a sharp image with a blurred one. This means that most successful photographs of movement are, in the broadest sense, multiple exposures.

Sometimes nature provides the multiple exposure for us. Hidden in many dance and sports movements is an instant in which there is very little action. Photographers with experience in documenting such events time the release of the shutter to coincide with those instants. Even though the shutter is opened only once, the frequent result divides the exposure into two fairly distinct parts: the nearly static instant and the fraction of a second of movement leading up to it. These still pictures convey the sense of movement so strongly that they make a good model for photographers who want to use special effects to simulate movement.

Sharp Image, Plus Blur

Simulating movement means making a static image on film or paper appear to be moving. The physical subject may or may not move when the picture is shot. Sometimes subjects really do move. Moving subjects are the hardest to photograph, especially if we cannot control their speed. We will talk about them first.

Moving subjects are best lit with a combination of strobe, used on the leading edge of the subject, and continuous light on the trailing edge. Neither light source, used alone, produces both a blurred and a sharp image on the same film. Blurred images of moving subjects generally require continuous light sources. At the same time, sharp images of moving subjects require strobe light because using a shutter speed fast enough to freeze the movement in continuous light eliminates the blur. The exceptions to this are those movements, such as the swing of a golf club or the peak of a dance leap, that have nearly motionless instants in them. Even these, however, make much higher quality pictures if we can get the flash of a strobe to coincide with that instant.

When we combine strobe and continuous lights, the first decision is always what to do about color balance. Strobes approximate daylight color, but almost no continuous lights do so. No film records color accurately with both, regardless of any filtration on the camera lens. For moving subjects, however, unconventional color in the blur is often no problem.

Using daylight film to match the strobes and no filtration produces a nearly neutral-colored sharp image with a warm blur. The color in the blur makes it dis-

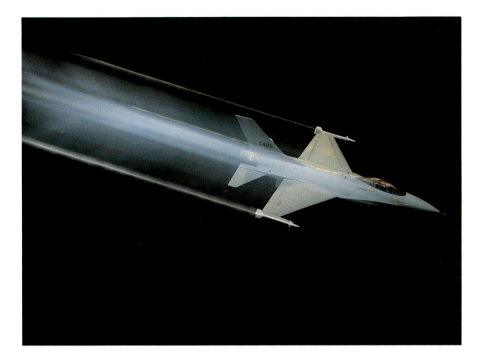

Figure 46 The fighter sits on black velvet. The movement is a shift of the view camera rear standard.

tinguishable from the sharp portion of the image. The increased distinction of the sharp image against the blur can be especially helpful if the subject is a white one.

If we decide that both the sharp and the blurred portions of the moving image need to have accurate color balance, one of the light sources must be filtered to match the other. The decision of which light to filter is best made after test exposures. Few studios are fully equipped with both strobe and continuous light sources. Test exposures may reveal that one source is, at best, just bright enough to use with the other. Filter the stronger source, and choose the film accordingly.

Notice that the effective brightness of the continuous lights varies with the moving subject. We base the exposure time on the length of the blur we want in the picture. During that time, a slowly moving object may produce an adequately bright blur under weak illumination. A faster subject needs a shorter exposure to make a blur of the same size, and very bright lights may be necessary for adequate exposure during that time.

The single greatest difficulty in combining strobe and continuous lights for a moving subject is synchronizing the strobe with the camera. A psychologically convincing still picture of movement requires that the blur trail behind the moving subject. Unfortunately, almost every camera shutter triggers the flash at the beginning of the exposure time, not at the end. This creates a photograph with the sharp part of the image at the beginning of the path of movement. In such a picture, the subject seems to be going backward.

Some subjects make it simple to work around this problem. If, for example, the subject can move equally well in either direction, move it backward. Reversing the physical movement puts the shutter-triggered flash at the apparent end of the path of movement where viewer psychology demands that it be. (This method also corrects the potential effect of acceleration on the brightness of the blur— more on this to come.)

Slow-moving subjects allow manual triggering of the strobe. Coordinating the action usually takes two photographers. One opens the shutter at the appropriate point along the path of movement. The other waits for the subject to reach the end of that path, then simultaneously flashes the strobe and turns off the continuous lights. (Turning off the continuous lights prevents additional blur ahead of the sharp portion of the image if the subject is still moving.) In darkness the first person then closes the shutter.

If the subject cannot move backward and moves too fast to coordinate manual triggering of the strobe, proper timing of the flash is impossible with standard equipment. If the subject must move, we need either a camera shutter that is able to trigger the flash at the end of the exposure time or sound- or motion-sensitive switches by which the action of the subject can trigger the strobe.

Specially designed switches are commonly used by photographers specializing in scientific and technical documentation; special effects photographers may buy, build, or rent such controls, but they are more likely to build a fake subject whose movement they can control if the real thing does not permit it! If you do find it practical to design special switches, remember that they should turn off the continuous lights a fraction of a second before they flash the strobes to keep the blur from degrading the sharp part of the image.

Controlled Subject Movement

Subjects used in special effects pictures frequently do not move under their own power; a spacecraft is more likely to be a miniature than a real one. Because special effects normally require test exposures to refine the procedure, controlling the speed and direction of the movement is critical. Tests are worthless if the subject behaves too differently in each trial.

Equipment to precisely control the movement of a miniature is seldom economical for still photography. Devices built to precisely move and position the subject pay for themselves when they are used to expose thousands of frames of film in a motion picture with a multimillion dollar budget but not to expose a single sheet of film on a budget of, at best, a few thousand.

However, even still photographers are likely to have one very precise positioning tool: the view camera. Moving the film is usually easier than moving the subject. Many cameras are calibrated finely enough to allow starting and stopping a movement within a fraction of a millimeter of the desired point. Rack and pinion movements are smooth enough to repeat at the same speed, with the help of an assistant with a stopwatch.

Cameras with revolving backs are best for simulating subject movement. The subject movement usually needs to be a diagonal on the film, and view cameras allow good control of only vertical or horizontal movements. Tilting the camera turns either of these into a diagonal movement. Then, squaring the camera back with the ground puts the scene back on level.

Many photographers do not use view cameras, and on rare occasions, we want a longer subject blur than the view camera allows. In either case we can use a tripod pan instead of a rear standard movement. The effect may be as good, but not necessarily. Tripods intended for still photography are seldom made with the precision of a view camera.

Simulating subject movement with the camera has two important limitations. We cannot easily produce a movement of the subject toward or away from the camera; virtually no still studios have a good camera dolly. Furthermore, if the

Figure 47 This photograph illustrated a magazine article on bank fund transfers. The same coin was photographed twice, with camera movement.

subject is in an environment, moving the film causes the whole scene to move with the primary subject; using the camera to move the subject requires using still another effect to add the environment without movement.

If we have to move the subject instead of the camera, creative engineering is essential. Unless we routinely photograph similar subjects moving similar distances, each assignment is likely to require a different combination of common hardware, crude assembly, and patient execution. Here are some general hints:

1. Almost always make the sharp portion of the exposure first. That is the one that needs accurate positioning on the film; it is easier to start a movement at a precise point than to finish at one.

2. During the sharp portion of the exposure, light the whole set with whatever type of lighting is appropriate. Then during the blur portion of the exposure, light only the path of the moving subject with a narrow beam from a spot light. Other qualities of light are usually unimportant for the blur, so diffusing the source is unnecessary. This keeps the light off the rest of the set so that the back-

ground will not expose the film area occupied by the sharp portion of the exposure and make the subject appear transparent.

3. If you pull a subject in the scene, with thread, attach the thread to the rear and pull the subject backward. The blur then conceals the thread.

4. A tripod or light stand dolly intended for still photography may move smoothly enough to support a moving subject with a track to guide it. Make a track by taping pairs of metal strips to the floor.

5. A supporting rod covered with black velvet needs to be in a dark area of the scene only during the sharp part of the exposure to remain invisible. During the blur, the black velvet support can move across brighter areas without exposing itself.

6. If you need to motorize the movement, an ordinary variable speed electric drill may serve the purpose. Buy any standard diameter electric motor pulley on a shaft to fit the drill chuck. The pulley can wind up a cable or thread attached to the moving subject with a reasonably smooth movement if the subject is not too heavy for the drill motor. Clamp the drill to a solid support, and adjust the speed so that the rate of movement allows proper exposure for whatever continuous light source you are using.

7. If you need to time the movement, plug the electric drill or the continuous lights or both into a darkroom enlarger timer. (Read the recommended maximum current load on the timer's specifications plate! High wattage lights will damage the timer.)

You can also use a variable solid state timing relay to do the same thing as the darkroom timer. Such relays are relatively inexpensive. They are available in models that will take up to 1200 watts with time settings from 1 second to 24 hours.

8. If the subject is not heavy and needs to move over a smooth surface, consider putting a magnet in it and using another magnet under a thin table to move it. Working under a table makes movement more difficult to control, but it eliminates the need to conceal or retouch hardware.

9. If the subject is on wheels or if wheels can be concealed under it, consider tilting the whole set. Tilt the camera similarly to level the scene, then let the subject roll on its own apparent power.

Acceleration

The preceding discussion assumes that the subject is moving at a constant velocity. This produces a blur of uniform brightness. Sometimes, however, we might prefer that the blur be brighter near the subject and disappear gradually at some point earlier in the path of movement. Furthermore, if we are using an electric motor to move the subject, inertia prevents the subject from attaining full speed at the beginning of the movement. The gradual acceleration of the subject will produce an unevenly bright blur whether we want it or not.

The most important fact to remember about subject acceleration is that the subject produces the brightest blur while it is moving slowly. As the subject speeds up, the blur gets dimmer. A rapidly moving subject will not expose the film enough to create a visible blur at all.

This means that a subject accelerating forward makes a blur that tends to disappear close to the subject. The best illusion of movement requires exactly the opposite. Therefore, if we want increasing acceleration to gradually diminish the visibility of the blur, we have to move the subject backward. (As we pointed out earlier, moving the subject backward also satisfies other needs.)

If we are moving the subject by hand, we can also move it in its proper direction and gradually slow the movement as the subject approaches its final position.

Either way, use acceleration with caution. The portion of the blur superimposed over the subject reduces its legibility. If that part of the blur is the brightest part, it obscures the subject even more. When the subject needs good visibility (a product being advertised, for example), it is usually better to use little or no acceleration.

Other Motion Illusions

There are two other movement effects that sometimes produce good illusions in a still photograph. Both of them duplicate the results of photographing real moving objects in specific circumstances.

Figure 48 The steps between exposures increase with acceleration. This accurately represents real acceleration, but it seems backward psychologically.

Figure 49 Reducing the steps between exposures as the motion progresses creates a more convincing illusion, despite the fact that it is mathematically incorrect.

Photographers often pan the camera to follow a fast subject such as a race car. The result is a much sharper picture of the subject but with a blurred background. We can duplicate this effect in the studio but usually not with the same technique. At closer distances perspective changes too much with the movement of the subject. Even if the pan perfectly matches the speed of the subject, the subject will not be sharp because the apparent shape of the subject changes too much during the exposure time. Instead, try keeping the subject still and moving the background. The effect then will be identical.

The other motion effect worth considering is that of a rapidly flashing strobe. A series of sharp images along the path of movement creates an illusion as good as a blur for some subjects. If the subject is not actually moving, we can duplicate

the effect by successively repositioning the camera or the subject and re-exposing the film. When we do this, we have to remember the effect of acceleration, then do the opposite of what physics suggests we should.

If a strobe is flashing at regular intervals, an accelerating subject will produce images farther and farther apart. Thanks to an evolutionary quirk in the human brain, the subject in such a photograph appears to be going backward. Satisfying the psychological needs of the viewer requires positioning the images closer and closer together as the subject progresses along the path of movement.

CHAPTER 4

OPTICAL EFFECTS

The special effects covered in this chapter depend on the physics of light for their execution. Examples include using the optical properties of some materials to diffuse, color, or in some other way manipulate light and using a lack of depth of field to blend subjects together.

During these techniques the camera lens is sometimes used as more than just a part of an image recording device. For example, the camera may be used as an enlarger or a projector. In other cases an enlarger or a projector may be used with a camera or in place of it.

FILTERS AND GELS

Filters are among the most useful and least expensive special effects tools available. We have already discussed diffusion and star filters because they are essential to other effects. They are, however, by no means the only useful filters. The following is a brief summary of the available filter effects.

Gels color individual light sources in the same way colored filters on the lens color the entire scene. If all lights are gelled with the same color, the effect is identical to that of a filter on the lens. Gels are less expensive though because they need not have the high optical quality of a filter covering a lens.

Filters and gels are routinely used in special effects. However, using either usually does not, by itself, produce an interesting effect. They are more often used to enhance other (often more important) effects. For example, many photographers like to use a diffusion filter over the lens, at least during part of the exposure, to enhance a scene with fog, movement, rays, and glows. Blue filtration, with careful lighting and reduced exposure helps to enforce an illusion of night. Gelling the lights with almost any color is often useful for photographing different subjects that will be combined into a single image; coloring all of the elements similarly makes them look more likely to have actually been in the same place and unifies the scene.

Filters are often used in combination with each other and with gels. When you look at a filter manufacturer's catalog, do not confine your analysis of what you see to the images before you. Do not just consider each example as it exists, but ask yourself what kind of effect a combination might produce.

Remember, though, that any filter degrades sharpness slightly and may increase flare greatly. Stacking one filter on the lens after another multiplies these defects. Because many special effects include diffusion or other deliberate degradation of the image, one more defect may not matter. But beware of using too many filters when the image quality needs to be high.

Filter Systems

A number of filter "systems" are available on the market. Essentially they consist of nothing more than some kind of holder that attaches to a camera lens and the filters that fit in it. Because all of the filters in the system fit the same holder, they can all be made the same size and used without any mounting hardware on the filter itself. Because the makers and the retailers do not have to maintain an inventory of different sizes, they can offer a much greater variety of effects with the same warehouse and shelf space.

To photographers, having the whole system the same size can be either its biggest advantage or its biggest drawback. If you only use small lenses, it is nice to have one set of filters to fit everything. The ability to switch from one diameter lens to another without having to dig out a different size version of the same filter is a definite advantage in terms of both savings and convenience. However, a high percentage of photographers interested in special effects use view cameras. Lenses for these cameras tend to have large diameters and require still larger filters to avoid vignetting by tilting or shifting the lens. At present, none of the filter systems meets this need.

Filters and Color Negative Film

One thing to consider when starting to experiment with filter-based special effects is the film you are using. Prints made with automatic print-making machinery are automatically corrected to produce prints that look "right." Amateurs routinely buy machine prints, and professionals sometimes use them for proofs and for jobs such as weddings that require a large number of prints.

When confronted with a negative that contains too much cyan, for example, the automatic printer "corrects" the print for you. If that cyan negative was a result of your deliberate use of a red gel, too bad. The remedy is simple. Either shoot a transparency film or buy prints from a lab that understands what you have done and what your expectations are.

A Sample Collection

There is a wide range of filters on the market, but as numerous as they are, all filters fall into two basic categories. They produce either color changes or a specialized optical effect, such as multiple images.

Color Change Filters

Several different kinds of color change filters are available, and they are among the most useful. Most add a single color to a scene. A variation on this theme comes in the form of differently colored petroleum jellies and varnishes that can be applied to any filter.

Gels on the lights may be used with or in place of filters on the lens. The chief advantage of gels is that they do not require you to color the whole scene. Using a gel on one light while keeping the other lighting neutral allows true color in part of the scene and may appear more natural. Using a warm gel on the main light and a cool gel on the fill light allows higher visual contrast with lower lighting ratios.

Graduated color filters are available in a wide range of colors. One part of the filter is clear, and the other is colored. This allows you to add color to one part of the scene while leaving the rest of it unaltered.

The color of some filters can be adjusted. Vari-color filters incorporate a neutral polarizer. Rotating the polarizer produces a gradual shift from one color to another. A red/blue Vari-color filter, for example, allows the selection of red through every shade of purple to blue.

Optical Effect Filters

A number of filters are available that change the way a scene looks in some manner other than its color. These can be used alone or with a colored filter. Multi-parallel filters are typical of the kinds of optical filters available. They create a series of identical images of the same scene arranged in parallel. Double exposure filters, actually a filter holder with a movable slide, block out one part of the scene while the rest of it is shot. This allows you to place the same subject in different parts of the scene by making two exposures without advancing the film. **Multi-image** filters can be used to multiply the number of images of the same subject in the shot.

DIFFUSION

We tend to associate diffusion with soft, misty, romantic subjects. Such images are often very effective for setting moods. Diffusion can also have very practical uses. Designers of advertisements or book covers frequently use diffusion when they want to superimpose type directly over a picture; an unsharp image does not compete with type or make it illegible. Special effects photographers often use the same principle to hide defects; hand-built models, for example, require less realistic detail if they are diffused.

The degree of diffusion depends on the filter selected. At one end of the scale are those filters that produce nothing more than the slightest softening of contrast with no particularly notable loss or suppression of detail. We find such diffusion equally useful indoors or out. Diffusion can be used, for example, to soften skin texture and hide minor flaws. Diffusion filters are equally useful outdoors when you want to soften the look of a landscape without losing too much detail in it.

At the other extreme, filters are available that produce an extreme softening or reduction in contrast. The results of intense diffusion can be so extreme that they are totally removed from what we normally perceive as reality. In addition you can of course always mount several filters together to achieve more diffusion than any single filter produces.

Simple Diffusion

One principal diffusion method is to break up the image by filtering it through any optically inferior material: crinkled plastic sheets, window glass sprayed with clear lacquer, nylon stockings—whatever material your creativity or perversion leads you to try. Each material has a subtly different effect.

Not only does the degree of diffusion vary but so does the effect on different tonal values. Some diffusion materials have a greater apparent effect on the highlights, and others affect the whole tonal scale almost equally. For example, black mesh filters produce diffusion without the halo around highlights against a dark background that is associated with other diffusion methods.

If you find an effect you particularly like, you will probably also find that some manufacturer has approximated that effect with a plastic or glass filter. All the major photographic filter manufacturers sell a selection of diffusion filters.

PRODUCTION SUMMARY

Lightning

This lightning has been used with other elements in a number of special effects photographs. (It pays to keep a library of commonly used picture elements: lightning, stars, sunsets, planets.) We wanted more than one color in the lightning bolt. This made diffusion almost essential. Re-exposing the film to successive colors, without any other changes, would produce a single color, a mixture of its components. Using a different type of diffusion in each exposure gave each color a different width and sharpness, maintaining some distinction between them.

The original lightning was scratched into the surface of a piece of black painted glass, positioned in front of the camera, and illuminated from the rear. Four exposures were used for this transparency; many other colors and types of diffusion could also have produced good results.

Exposure 1: The lightning is slightly diffused by a piece of frosted Mylar. The light source is white, and the exposure is very weak.

Exposure 2: The lightning is diffused by a piece of glass speckled with clear lacquer, and the light source has a yellow gel.

Exposure 3: The lightning is covered by a quarter-inch-thick piece of translucent white plastic, and the light source has a red gel.

Exposure 4: Everything but the source of the lightning is masked by black paper, the lightning is diffused by the white plastic, and the light source has a light magenta gel. Heavy exposure puts the larger glow around the lightning source.

Some photographers prefer the commercially available filters because their effect is consistent and repeatable. Not only is a glass filter more durable than a piece of crinkled acetate, but if the glass filter gets broken we can go and buy another exactly like it. Other photographers prefer homemade filters *because* each one is slightly different. They believe the uniqueness of their diffusion is meaningful and important to their work.

Soft Focus

The other principal diffusion method is soft focus. The effect resembles both simple diffusion and accidental lack of focus, but it is not identical to either of these. A soft focus filter has many miniature lenses molded into its surface. These superimpose an unsharp image over the sharp one produced by the camera lens. The underlying sharp image may not be visible, but the highlights are likely to be whiter, and the general contrast is likely to be higher than in a comparably soft image produced by simple diffusion.

The quality of the underlying sharp image is essential to the soft focus effect and cannot be easily duplicated by homemade materials. The best soft focus fil-

Figure 50 A Carl Zeiss Softar filter.

PRODUCTION SUMMARY

Out of Body Travel

This photograph was used on the cover of a paperback book. Grease-smeared glass gave local diffusion to some of the glows in this scene. The combination of soft and sharp areas in the glow resembles smoke with dust particles and is more believable than if the glow were entirely sharp or entirely diffuse.

The actress's bald head was prosthetic makeup. The costume was two long rectangles of cloth, draped experimentally until it looked right. Three principale exposures were made on one sheet of film.

Exposure 1: The model in the doorway, almost entirely backlit, is shot with slight diffusion on the camera lens. An alcohol vapor fog machine just beyond the doorway sends a trail of fog through the door into the foreground. Black paper surrounds the door and covers the foreground floor, but not over nearly as large an area as it appears in the photograph. A black card with a small window is in front of the camera to block the camera view of the studio area not covered with black paper.

Exposure 2: The smoky glow is black spray paint on tracing paper, illuminated from the rear by lights with colored gels and shot through glass with a few clear grease smears to diffuse part of the glow.

Exposure 3: There is actually two exposures: a pinhole star field on a light table is photographed with and without diffusion on the lens.

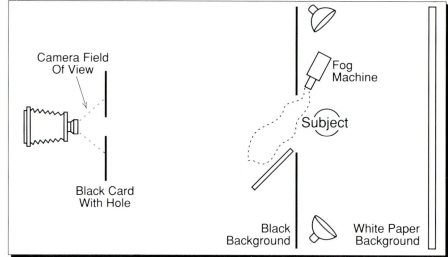

ters are fairly expensive. Still better but much more expensive are specially designed camera lenses with soft focus optical elements built into them.

Some photographers consider soft focus to be greatly superior to simple diffusion and essential to their style. Others think the distinction is trivial. Still others agree that soft focus is preferable but not enough to be worth the cost. All of these decisions are logically defensible, so pick the one you like.

Local Diffusion

Sometimes we want only a part of the image diffused. Photographers usually accomplish this with a sheet of glass smeared with petroleum jelly just in those areas that need to be unsharp.

The farther the diffusion glass is from the camera, the more localized the diffusion can be. (The exact distance between the glass and the camera lens depends on depth of field. The principles determining that distance are identical to those for positioning a vignetter, which is discussed later. Those principles are less critical for petroleum jelly diffusion, however.) If we use a large-format camera or a wide aperture, the sheet of glass may need to be more than a foot from the camera. Using a small camera or a small aperture, an ultraviolet (UV) filter smeared with petroleum jelly and screwed directly to the camera lens may work.

A few commercially available filters offer partial diffusion. One type is called *center spot.* It diffuses the outer edge of the scene while keeping the center of the picture clear and sharp. This filter can force attention on the subject or reduce the distraction of a cluttered background. Another type has only one half of the filter diffused; the other half is clear. In landscape photography, this filter can produce a picture with a clear foreground and with distant objects that look as though they had been shot through a mist or haze.

Another way to produce local diffusion is by multiple exposure. One exposure has no diffusion while the other is completely diffused, and each exposure has a different part of the scene lit. **Figure 51,** which shows books in an alien landscape, is an example.

Flare

Flare is light that strikes the film but is not part of the image. It comes from light scattered inside the lens or reflected from inside the camera. Generalized flare reduces contrast; extreme cases look like fogged film. Any filter may increase flare, but diffusion on the lens is almost certain to do so. Diffusion on the lens, especially heavy diffusion, must be handled more carefully than any other filtration. Keep the light sources illuminating the scene from illuminating the lens. Use a lens hood as deep as possible, or arrange gobos between the light source and the lens. If ideal lighting prevents keeping illumination off the lens, attach the diffusion to the back of the lens instead of the front. The diffusion effect is similar, but no extraneous light can strike the filter.

"Post-Production" Diffusion

The darkroom provides the same opportunities as the studio, plus a few more. Try putting the same filters that you use in front of the camera over the enlarger lens. You can also experiment with pressing a sheet of diffusion material, such as frosted acetate or Mylar™ against the paper while making a print. Either of these

Figure 51 The background planets, airbrushed spheres, needed diffusion to conceal detail and to appear to be seen through an atmosphere, but the product had to stay sharp. This required two exposures. In the first, the foreground was recorded sharply while the background was kept in darkness. During the second, diffusion was added to the lens and the planets were illuminated while the foreground lights were kept off. By using multiple exposures, lighting each differently, any area of a scene may be diffused while the rest is sharp.

is likely to reduce the contrast and gray the highlights more than using a similar technique while shooting. Nevertheless, the effect could be superior, depending on the specific image and your personal preference.

VIGNETTING

Vignetting uses a piece of cardboard or other material in front of the lens to block the camera's view of part of the subject. The vignetting device is kept close enough to the lens to be out of focus. Because the vignetter produces no sharply defined edge, the obscured part of the scene disappears gradually instead of being sharply cut off.

Vignetting is most commonly used by portrait photographers to get rid of distracting body parts and center the viewer's attention on the face of the subject. Special effects photographers sometimes use the disappearance itself as the effect. Others use vignetting in combination with multiple exposure to blend subjects together.

Figure 52 This photograph illustrated a "Convention Notes" article in a professional association magazine. Vignetting blends the gavel (the annual convention) and the pencil (notes).

Vignetter

Figure 53 The gavel exposure for Figure 52 was arranged as shown. The second exposure, for the pencil, was done similarly.

Choosing the Vignetter

The material used to make the vignetter must almost always match the appearance of the background. This is because we do not want the vignetter itself to become a visible element in the scene. We want the viewer to see a disappearing subject, not a subject blocked by a piece of cardboard. No matter how unsharp the image of the vignetter might be, if its color or tone is drastically different from the background its presence in the scene is obvious.

This means that black vignetters and black backgrounds are the easiest to use because it is the only combination of vignetter and background that does not require that the vignetter itself be lit to match the background. Indeed, this is exactly the combination generally favored for special effects because the black areas in the scene also simplify multiple exposure.

If the vignetter-background combination is not black, we need to light the vignetter to the same brightness as the background. A white vignetter with no light on it becomes a black vignetter in the photograph.

The side of the vignetter that faces the lens can be hard to light. Finding a place to put the light without casting a shadow of the camera on the vignetter is sometimes difficult. This is especially true when we have great depth of field and the vignetter has to be very close to the camera to keep it sufficiently out of focus. Furthermore, the light that illuminates the vignetting device can also add light to the subject, possibly from a direction we do not want.

If the background is neutral gray or white, we can simplify lighting the vignetter by using a translucent white one instead of an opaque one. Some of the lighting of the subject then passes through the vignetter. The brightness of the vignetter is closer to that of the background even in the preliminary lighting. Adding more light to the translucent vignetter is easier when we have the options of lighting it from the front or the back. Reducing illumination on the vignetter requires a gobo between the vignetter and the light source; a gobo so positioned almost never interferes with other lighting needs.

If the background is colored, matching that color with the vignetter almost always requires cutting the vignetting device from the same material used for the background. Because few background materials are translucent, the side of the vignetter facing the lens must be lit.

Positioning the Vignetter

The best position of the vignetting device between the lens and the subject is determined entirely by the amount of depth of field. Great depth of field requires placing the vignetter close to the camera to keep its image soft enough; shallow depth of field requires moving the vignetter closer to the subject to keep it from being so out of focus that the subject shows through it.

When we photograph a single subject, it does not matter how much the vignetter is out of focus, within a wide range. However, if we are using vignetting with multiple exposure to blend subjects together, the degree of focus becomes critical. The edge of a subject disappearing into another needs to fade away at the same rate at which the other appears. Otherwise, the transition between them will be too uneven to be believable.

In addition to aperture, depth of field is influenced by the size of the image compared to the size of the subject. As the image size increases, the depth of field decreases. It does not matter whether the increase in image size comes from using a longer lens focal length or moving the camera closer to the subject. Thus

PRODUCTION SUMMARY

Dream within a Dream

This picture was created for a brochure on a series of books on strange, spooky, and unexplained events and phenomena. The lead book was about dreams, and the picture was intended to depict the borderline between the dream world and the real world. For such a soft subject, vignetting was perfect for eliminating unwanted parts; masking, which is more time consuming, unnecessary.

A set of transparencies was made of the actress in front of a black background. One was selected for expression and body posture, another for the extended arm. A deliberately underexposed black and white transparency was made from the one selected for expression and posture.

Exposure 1: The color and black and white versions of the body transparency are sandwiched, placed on the light table, and covered by a piece of white glass. Diffusion by the white glass also greatly reduces the contrast of the image; the underexposed black and white transparency adds density to the blacks, regaining some of the lost contrast. We then cut off the lady's arm with a vignetter under the light table.

Exposure 2: Moving the film to a second camera over another light table, we copy the arm transparency. This time a vignetter under the light table eliminates everything but the arm. A spot of clear grease on glass slightly diffuses the sharp arm just at the point at which it disappears.

Exposure 3: In a third camera, the film is re-exposed to a piece of rear-illuminated brown wrapping paper, highly magnified.

when we attempt to blend two subjects of different sizes, we must adjust either the vignetter position or the aperture as we change subjects.

To get two subjects to a similar size, we have to move the camera closer or use a longer lens for the smaller subject. If nothing else changes, the photograph of the smaller subject will have less depth of field and will fade away more gradually than the larger one. To make both subjects disappear at the same rate, we have to either use a smaller aperture for the smaller subject or place the vignetter closer to the smaller subject.

Vignetting a Rear-Illuminated Image

The easiest image to vignette is a rear-illuminated transparency. We can put the vignetter behind the translucent surface, which diffuses the vignetting device, and we need not worry about the depth of field. We still have good control over the sharpness of the vignette by adjusting the distance between the vignetter and the translucent surface. The closer the vignetter is to the surface, the sharper the boundary of the vignette becomes. If we want a nearly sharp vignette, we can attach the black card directly to the back of a thin white plastic sheet. To soften the boundary, use a thicker sheet or move the vignetter farther away.

IN-CAMERA MASKING

In-camera masking is a double exposure technique that, through the use of a movable in-camera transparency holder, can combine two separate images on one sheet of film. **Figure 54** is an example. The fireworks were on an existing transparency. The in-camera masking device allowed us to copy the existing transparency while simultaneously photographing a three-dimensional subject. The three-dimensional subject served as its own mask to eliminate unwanted parts of the background transparency.

In-camera masking offers major advantages over any alternative process. The principal subject, at least, is first generation, leading to none of the quality loss inherent in laboratory techniques that require duplicating the transparency. The edge of the foreground subject against its background is completely photographic; there is no need for blending or retouching. In-camera masking completely eliminates lab services beyond basic film processing, and thus time and money investments are reduced.

In-camera masking is a logical replacement for photomechanical and electronic assembly techniques provided that the subject and composition meet two critical requirements:

1. The subject must be still enough to allow two exposures without movement.

2. The composition must allow the subject and background to be lit separately. This generally means the subject cannot sit on the background.

The Equipment

Several in-camera masking devices are available on the market. All of them go into a view camera just as a film holder does, and they hold an existing, processed background transparency in front of the unexposed film. The holder with unexposed film slides between the ground glass and the in-camera masking device.

The in-camera masking device goes into the camera before focusing. The thickness of the device prevents the film from occupying its normal plane. Having the device in the camera while focusing lifts the ground glass by an identical distance, and thus automatically compensates for potential focusing error. (*Hint*: An in-camera masking device without a transparency in it allows focusing in those situations when we have slightly too little bellows draw for the lens and viewing distance we are using.)

Some in-camera masking devices mount the transparency in a hinged metal frame. An external knob allows the background transparency to swing into contact with the unexposed film, then out of the way inside the camera.

Other devices mount the background transparency in a thin cardboard frame that can be slid in and out of the camera like a dark slide. By removing the glossy film of the background transparency from the camera when it is not needed, reduces the chance of flare. Because this type of device does not hold the back-

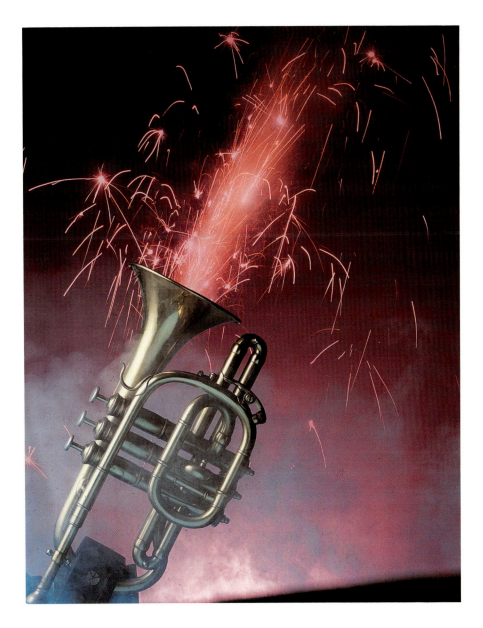

Figure 54 For this album cover, the fireworks were photographed two days before the cornet.

ground transparency in contact with the unexposed film when it is copied, many photographers expect the reproduction to be less sharp. However, the illumination, coming from the camera lens, is highly focused, and sharpness is quite adequate.

The Process

Figure 54 is the cover of a jazz album titled *Celebration*. The musicians wanted fireworks coming out of the cornet, but actually putting them there would have been a risk to the instrument. Furthermore, we would have had no control of the size of a real fireworks display. Getting the spray of sparks to the right size, relative to the horn, would have required experimenting with different types of fireworks until we got it right. In-camera masking solves all of these problems.

The fireworks were a small "fountain" shot against a black background in the studio a few days in advance. The film was processed, and one transparency was selected to use with the cornet. (One fountain filled the room with too much smoke to photograph any more. During the single burn, we exposed 4 × 5 film as fast as possible to ensure one good shot.)

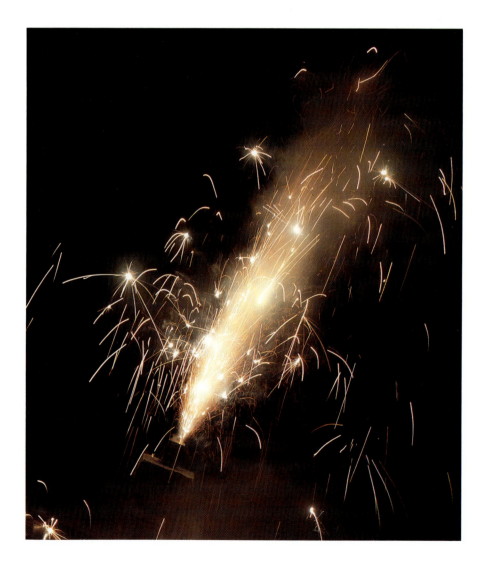

Figure 55 Fireworks before combining with cornet. Using a magenta background instead of the customary gray or white one added color to the fireworks in the finished picture.

Figure 56 The first exposure for the in-camera masking technique: the subject lit, the background black, and the background transparency in the camera but out of the way.

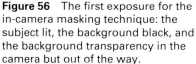

Figure 57 The second exposure for the in-camera masking technique: subject in darkness and background lit. The background transparency, in contact with the fresh film, gets copied.

Creating the final montage was a multiple-step process; each step was designed to expose a particular portion of the sheet of film we were using. Effectively, this added up to a double exposure in which the cornet, surrounded by smoke, was recorded on one area of the film, and the fireworks transparency was copied on another.

The first step was to attach the in camera masking device to the camera and rotate the control arm so that the 4 × 5 transparency we were going to use as a background for this shot was out of the film plane and out of the way. Next we positioned the horn the way we wanted it and lit it to keep the background dark. Figure 56 shows how we arranged the lights to do this; those illuminating the instrument were on and those that would illuminate the background were off. This sort of lighting arrangement usually also includes gobos to keep stray light off of the background and off the camera lens.

With the shot composed, we turned on the smoke machine and made the first exposure of the cornet and the foreground smoke. Then after clearing the smoke but without inserting the dark slide or moving anything, we turned the first

strobes off and others on. For the next exposure the cornet was dark and the background was illuminated. **Figure 57** shows this arrangement. We then adjusted the in-camera device to put the transparency of the fireworks in the film plane and in contact with the film on which we had just exposed the cornet.

For the second exposure the dark form of the foreground subject acted as a mask to prevent that part of the film from being re-exposed while we recorded the fireworks on the part of the film that had seen only black background in the first exposure. For this shot we choose a lavender background color. Had it been important to reproduce the color of the fireworks accurately, we would have needed a neutral background. Medium gray paper is usually good for in-camera masking because it is easy to light so that it photographs either black or white. If the physical arrangement prevents lighting a gray background both ways, then we must use white and black paper, changing the background between exposures.

In-camera masking normally copies an existing transparency as a background behind some other subject. However, it is also possible to bring some of the back-

PRODUCTION SUMMARY

Wright Flyer on CAD System

In-camera masking combined the foreground airplane model with a background computer screen of a computer-aided design (CAD) image of the plane.

Production of the background transparency was more difficult than the final image. In the days when this photograph was made, an image like the one on the screen could not easily be displayed on a small computer system that could easily be set up in the studio. But the system that actually produced the image was in a small cubicle that was difficult to light, and it was impossible to use a large painted background.

Furthermore, in-camera masking means photographing the foreground subject in the last step, after the background transparency is prepared. But this scene required that the computer operator have the photograph of the foreground subject first, to ensure that the perspective of the image on the screen matches the real thing.

Step 1: We photograph the airplane model, suspended with monofilament, make a black and white print, and send the print to the computer operator, who begins work on the screen image.

Step 2: In the studio, a transparency is exposed of a blank computer

ground transparency into the foreground or to blend it with the foreground subject. The Wright flyer is an example of this.

REAR PROJECTION

Rear projection uses a translucent screen behind the subject. A projector on the opposite side of the screen provides the background image. Carefully executed, the result is indistinguishable from a picture of the subject photographed in the background location. The edge of the foreground subject is believable because rear projection has no special influence on the delineation of the boundary between the subject and the background. That edge has exactly the same degree of sharpness it would have if the foreground subject were photographed in the background scene or with no projected background at all.

Rear projection requires no special hardware to align the projector with the

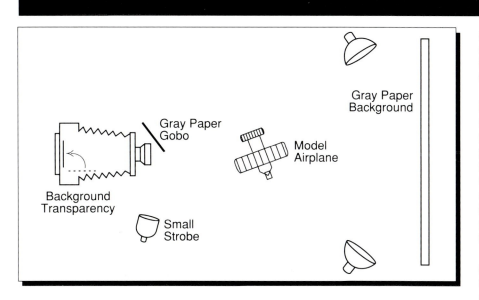

monitor in front of a painted background, with some alcohol vapor fog creeping into the foreground and lit to match the background. The lighting keeps the blank screen dark, so that the screen image can be re-exposed on the same film. The camera ground glass is marked with a grease pencil for approximate registration with the screen image later on. At the same time, several sheets of Polaroid film are exposed, but not processed, to be used for more precise registration.

Step 3: The exposed, unprocessed transparency of the computer in the studio is carried to the location of the larger computer system. The camera

is positioned so that the screen image registers with the blank screen of the studio computer using the ground glass markings, then it is fine tuned using the Polaroids and trial and error.

With the room totally dark, the new screen is re-exposed on the trans-parency of the studio computer. After processing, this transparency becomes the background to be used for in-camera masking.

Step 4: The camera that shot the first black and white of the suspended model is still in position. We now use the same set for the final transparency. The background transparency is combined with the fore-

ground subject, using two exposures like any other in-camera masking operation, but with one special twist.

A tiny gray gobo in front of the lens blocks the camera view of the suspended model. During the exposure of the model, both the background and the tiny gobo are unlit to photograph as black. If this were the only exposure, the result would be an image of the plane against a black background, with the left side of the plane gradually fading into blackness.

Then, when the background transparency is copied in the camera, the subject is kept dark and its background is illuminated to white, as usual. In addition, a small strobe illuminates the gray gobo so that it now provides illumination for the background transparency. The image on the computer screen in the background transparency reproduces exactly where the image of the model plane disappears.

In each step, the tiny gobo in front of the lens must be lit *exactly* as brightly as the background, if the elements are to merge well.

Step 5: For the originally intended use, the monofilament lines supporting the model plane were dot etched away by the color separator. We have left them in this example, so you can see just how little retouching is required to complete the image.

PRODUCTION SUMMARY

Street Crime

A news magazine wanted this picture. Even if the deadline had allowed time to stage a background scene, staged scenes are questionable for news purposes. They are acceptable only if they appear obviously staged to even the most gullible reader. The art director wanted a violently colored splash of light behind the pistol, but that was so obviously a *studio* treatment that it detracted from the message of *street* crime.

The solution was to photograph a night street scene in black and white and to make a print. We copied the print through a yellow filter onto color reversal film, then flashed that film by re-exposing it through a red filter to a blank white illuminated card. We processed the transparency, then projected it onto a screen behind the gun. The art director got his violent splash of color, and the picture got the street background it needed—but so abstractly that no one can accuse us of faking a news scene.

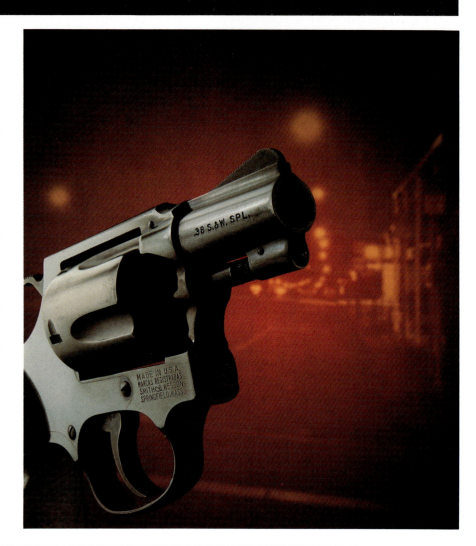

camera. The projector lens needs to be aimed at the camera lens for maximum brightness, but approximate centering is adequate.

One of the virtues of rear projection is that photographers can begin experimenting with it without any additional equipment investment. If they like the effect, they may later consider buying special equipment to improve efficiency. The projector itself does not necessarily need to be a specialized one. Its light source may be strobe or incandescent. An ordinary slide projector with color correction filters is usable if the subject is a still life and the photographer is willing to tolerate very long exposures.

Beyond experimentation, brighter projectors and faster projection lenses make rear projection practical for routine use. In selecting a brighter projector, remember that the brightness of the projected image does not depend entirely on the brightness of its lamp or flash tube. Projectors that use larger film also produce brighter images because the background transparency does not need to be enlarged as much. Photographers need to base their choice on a meter reading of the projected image, not on the watts or the watt-seconds of the light source.

Choosing the right material for the projection screen can determine the suc-

cess of the finished picture. Any diffusion material may make a good projection screen as long as it does not have internal fiber or grain structure coarse enough to be visible to the camera. However, this does not mean that any one material is best for all arrangements.

The principal problem with rear projection is exaggerated in **Figure 59**, which shows short focal length lenses on both the camera and the projector. Notice that the light striking the edge of the projected image has to greatly bend its path if it is to reach the lens of the camera. The whole purpose of the diffusion material used for the screen is to cause this bending. As the light reflects from the internal particles making up the screen material, a certain amount of it is sure to reflect toward the camera lens. Unfortunately, it is likely to be a very small amount.

The more the screen diffuses the light, the more even the brightness of the projected image becomes, but the dimmer it gets and the less sharp it becomes. To get a usably bright image, we have to use a diffusion material that diffuses the light just enough to allow acceptably even illumination, but no more. We have to be content with imperfect diffusers and accept the fact that all rear-projected images must be a bit dim at the edges.

One of the measures of the efficiency of a projection system is the total *bend angle* shown in **Figure 59**. The smaller the bend angle is, the brighter the projection system is. This justifies using lenses with focal lengths as long as possible on both the projector and the camera.

Figure 58 shows a brighter arrangement using such a lens selection. The angle at which light must bend at the edge of the image is smaller, so the screen does not need to diffuse the light so much to reflect it toward the lens. We need less diffusion to produce acceptably even illumination, and less diffusion means a brighter image.

Notice that the longer lens on the camera offers advantages in addition to the brighter, more even projected background. Positioning the camera so that the foreground subject has the same size it did with a shorter lens, we find that the background image becomes larger in the scene. The increased effective background size allows either projecting a smaller background image or moving it farther from the subject. Either one makes the job easier.

Projecting a smaller background image produces a brighter one. Whatever

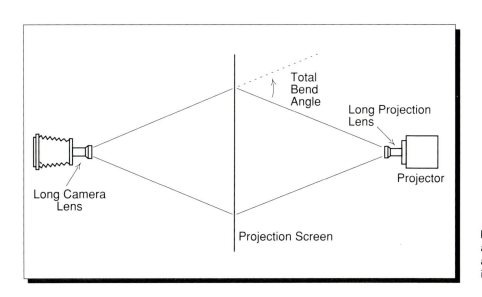

Figure 58 A standard rear projection arrangement. The smaller the bend angle, the more even the background illumination.

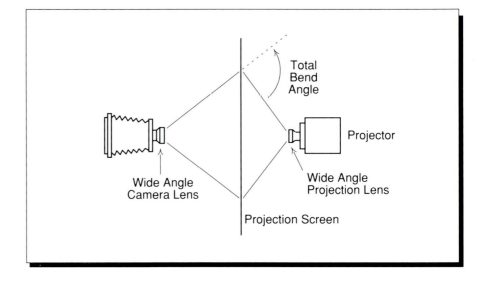

Figure 59 Using wide-angle lenses reduces studio space requirements for rear projection but causes less even illumination of the projection screen.

the brightness (meaning cost) of the projector, it is more able to compete with the brightness of the subject lights if it does not have to project an extremely large image.

If the projector is bright enough that there is no need to reduce the projected image size, then the projection screen and the subject can be moved farther apart. This makes it easier to keep the subject lighting from falling on the white screen and degrading the projected image.

Notice that all of the above considerations require more studio space. More floor space allows placement of the camera and the projector to permit using longer lenses. More distance to the surrounding walls and ceilings reduces the amount of subject lighting that strikes the projection screen. Small studios allow rear projection for only the smallest subjects.

FRONT PROJECTION

Front projection is the projection of a background image from the viewpoint of the camera photographing the foreground subject. In the resulting photograph, the foreground subject appears to be in the background environment. Like other background projection techniques, the foreground and background subjects are combined in camera. No additional time or money needs to be invested in lab techniques. Front projection produces a sharper image and requires much less studio space than rear projection. However, many photographers dislike front projection because of its special problems. A discussion of how front projection ideally works also reveals those problems.

Front projection requires three special pieces of equipment: a projector, a beam splitter, and a background projection screen, plus positioning hardware to align the projector and beam splitter with the camera. Some photographers modify general purpose projectors and make their own alignment hardware. Others buy complete front projection systems from photographic equipment manufacturers. The beam splitter is a lightly silvered mirror available from optical and scientific suppliers. The special front projection screen, which is much more reflective than other common materials, can be ordered from photographic suppliers.

As we see in **Figure 60**, the projected image reflects from the beam splitter to

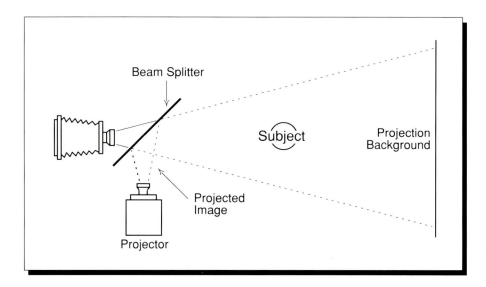

Beam Splitter

Subject

Projection
Background

Projected
Image

Projector

Figure 60 The front projection
system: camera, projector, screen, and
beam splitter.

the background screen. The angle of the beam splitter prevents the projected image from reflecting directly into the lens, and a black cover over the beam splitter keeps it from reflecting overhead light into the lens. To the camera, the beam splitter is transparent.

Assuming that the camera and the projector use the same film size, the focal length of the projector lens must roughly agree with that of the camera lens. If the projected image is to exactly fill the scene, the projector lens needs to be the same focal length as the one on the camera. A shorter projection lens will cause the camera to crop some of the background; a longer projection lens will not project a background large enough to fill the scene. Neither is a problem as long as we plan the crop accordingly.

The projector may have either a strobe or an incandescent light source. An ordinary slide projector may be adequate for a small still life scene, but projectors with strobes inside are almost essential for portrait and fashion pictures.

Photographers first learning about front projection are always puzzled by two questions: why don't we see the background projected on the foreground subject; and why doesn't the projector cause a shadow of the subject on the background? We do not see the projected image on the subject because almost no subject surface can reflect the image as brightly as the screen. When the lighting ratio is adjusted and the camera is set for a proper exposure of the subject and the background, the amount of illumination the subject receives from the projector is usually insignificant compared with the principal lights. A very glossy subject may show a reflection of the projector assembly in its surface, but this reflection is often too small to be noticeable by most viewers. Extremely precise alignment of the camera lens and the projector lens keeps the shadow on the screen directly behind the subject where the camera cannot see it, or so we hope.

Problems with Front Projection

The simplified diagram in **Figure 60** assumes that the projected background is perfectly sharp at any distance from the camera. Actually, the image is focused only upon the projection screen. The unfortunate consequence of this is that the shadow of the subject can never be perfectly sharp.

The slightly unsharp edge of the shadow of the subject always creeps slightly

out from behind the subject no matter how carefully the projector is aligned with the camera. The defect is unnoticeable to most viewers but only if the photographer works carefully to minimize it. This means that we must meticulously align the front projection system. Because refocusing either the camera or the projector changes the alignment slightly, we have to check it every time we change the distance between the camera, the subject, and the screen.

Another important precaution is keeping the subject lighting off the projection screen. The brighter screen materials are so reflective that even a minimal amount of subject lighting can degrade the background image. Barndoors, snoots, spot grids, or other light-blocking devices are essential.

We would like to tell you also to keep the projection screen as far behind the subject as possible to reduce the amount of light that can reach it. However, putting the screen farther away requires both a bigger screen and a brighter projector. Either of these may increase the cost of the front projection system beyond the budget of many studios.

USING PROJECTION WELL

A few technical considerations are equally essential to front and rear projection. The following techniques help to minimize the problems:

1. The most obvious difficulty of projection is keeping the lighting of the subject from illuminating the projection screen. The projection screen must be white. An amount of light too small to be readily detected can nevertheless fog the background image. We have to use gobos, barndoors, snoots, or spot grids to block any light rays from the rear of the set.

2. The farther the projection screen is from the foreground subject, the easier it becomes to keep the lighting of the subject from illuminating the background. Move the projection screen as far from the subject as possible, but realize that there are practical limits. For front projection, this requires a more powerful and more expensive projector, and moving any projected image farther from the subject costs depth of field.

3. Keeping the lighting of the subject from illuminating the background is easier if the subject is a still life. Because the subject does not move, we can expose the foreground and the background in separate steps. Cover the projection screen with black velvet while exposing the foreground subject. This allows almost complete freedom in lighting the foreground subject. Then turn off the lights on the subject, uncover the screen, and re-expose the film using the background projector alone.

4. Buy or build a projection system that will accept a large transparency if possible. Resist the inclination to use 35mm just because the size is convenient. Not only does a large transparency provide a higher quality projected image, but also a brighter one. A projected image of a 4 × 5 inch transparency is about nine times as bright as the same size image projected from a 35mm slide, assuming the same light source and the same projection lens aperture in each case.

5. Test the color balance of the projection system with the film you intend to use and filter the projector accordingly. Any projection system may cause a color shift and the degree of shift may vary from one batch of screen material to another.

Aside from avoiding technical defects, several artistic considerations improve the result of projection. Some are equally applicable to any other combined-image effect. The following is a brief list:

1. Match the subject lighting to the background lighting. In addition to direction and contrast, pay attention to the color of the background illumination. If the background was shot using sunset or any other nonstandard light color, you will have to filter either the subject lights or the projector to make the two match.

2. Keep the background from dominating the scene. Even the highest quality background will be at least one generation removed from the original when it shows up in the final scene. Seeing the first generation foreground subject makes viewers more aware of the quality loss in the background, even if they are unsophisticated. They know something is wrong even if they cannot say what it is. The less visible the background is, the less apparent the quality difference between it and the foreground.

3. Use background elements in the foreground. Furniture, plants, and any other props similar to background subjects increase the illusion that the foreground and background are the same scene.

CHAPTER 5

LABORATORY EFFECTS

Laboratory effects are produced either in the darkroom or with the aid of computer-based image manipulation systems. Most of these techniques involve copying existing photographic images to combine them with others or altering existing images by manual retouching or electronic manipulation.

None of these tools requires a camera, but in some cases one may be used for the sake of convenience. For example, the choice of contact printing, projection by an enlarger, or copying by a camera is often based entirely on the equipment and facilities available to the particular technician.

HIGH CONTRAST

There are many times when simpler is better, when simple has more impact, when simple is stronger. This principle makes high-contrast imaging a useful technique, when used alone or in combination with other images produced by other techniques.

Line Film

Black and white high-contrast images, such as the one in **Figure 61**, have only blacks and whites. They lack the middle tones, or grays, found in the continuous tone images. Even the simplest high-contrast image usually requires more than one generation. The time consumed by successive wet-to-dry steps makes photochemical contrast manipulation a logical candidate for replacement by electronic image processing. We will discuss the photochemical process because it is still commonly used. The principles are the same regardless of the type of processing.

Lithographic, or *line*, films are high-contrast emulsions designed for use in the printing industry. They produce *extremely* sharp, high-contrast images by eliminating halftones or gradations. These films are available in almost any sheet size and in 35mm rolls. Both orthochromatic and panchromatic versions are marketed. Orthochromatic films are sensitive to blue and green light but not red. Panchromatic films are sensitive to all colors the eye can see. This means that we can process orthochromatic film under red safelights and watch the development progress. For this reason, photographers use the orthochromatic version whenever possible. Only when the specific image requires red sensitivity— copying a transparency of a red subject on a black background, for example—do we use the panchromatic film.

Line films are also available in both positive and negative versions. Unlike other films, most positive line films can be processed in the same chemistry as the

Figure 61 The car was originally shot on conventional film and printed. This print is from a line film copy negative. Copyright Jeff Mathewson, 1991.

negative ones. However, the positive versions have somewhat lower contrast than the negative ones. This means that producing a very high contrast image requires going through two negative generations instead of making a single-generation positive. We will assume this is true for the following example.

Exposure

Depending on the circumstances, you can either shoot the original scene with a lithographic film, or you can copy an existing transparency or negative. For most subjects, copying an existing conventional image is more practical because of the low speed of line films.

If you are working with an existing transparency, place it in your enlarger and project it (at the size and with the crop you want) onto a sheet of lithographic film held in place with your regular paper easel. The result will be a lithographic negative.

If you are working with an existing negative, place it in your enlarger and project it onto a sheet of lithographic film. This time, the result will be a lithographic positive. This is an intermediary product, and when it is processed and dried you must print it onto another sheet of lithographic film to produce the desired lithographic negative.

Processing

Most line films require a special high-contrast developer and conventional fixing and washing. For small quantities of film, use the smallest developing tray possible, discarding and replacing the developer frequently. High-contrast developers are very active, and they involve mixing A and B parts. Once this is done, they quickly lose their potency.

For maximum sharpness, the developing time for line films is extremely critical. However, watching the development of orthochromatic film under red safelights allows you to closely approximate the ideal time with the first test. Inspect the developing image through the *back* of the film for the best evaluation. Unlike conventional films, the effects of changing exposure or development are almost

identical within broad ranges. Adjust either one to fine tune the density of the image.

Retouching

The extreme contrast and sharpness of line film clearly reproduces dust that would be invisible with any conventional film. If optimum sharpness is not important, we can sometimes eliminate some of the dust by overdevelopment. Even so, the processed negative is likely to have at least a few unwanted pinholes or spots. Fortunately, it is easy to remedy this by painting the spots with opaque fluid designed for the purpose. Use the same fluid to get rid of any unwanted subject matter in the scene.

We can also scratch the film with a blade or needle to open up clear areas in the black emulsion. The scraped areas in the clear film base will usually not reproduce in subsequent high-contrast generations. If we want to reproduce the line film on a conventional film, we first duplicate it on a positive line film to get rid of the film base scratches, then use the dupe.

Working with a High-Contrast Negative

Uses for the high-contrast image are limited only by the imagination of the photographer. A print from the high-contrast negative may be an end in itself, or the image can be added to a conventionally rendered scene through multiple exposure or any other image-combining technique. High-contrast negatives and positives can also be copied onto color film through strongly colored filters. **Figure 62** is a double exposure of a negative and a positive, each through a red or yellow filter.

High-contrast manipulation is simple to learn and requires little or no specialized equipment. Nevertheless, it is a powerful tool that can produce interesting and useful results.

Figure 62 Line film negative and positive, each copied through separate exposures onto a sheet of color film using colored filters. Copyright Jeff Mathewson, 1991.

FLASHING

Flashing means deliberately exposing film to nonimaging light. It is a controlled version of what happens to film when we accidentally open a camera without first winding up the roll or when we remove the dark slide on a sheet film holder we think is empty. The word comes from the printing industry where the technique is commonly used to raise the shadow density on halftone negatives.

In special effects, flashing is used to reduce the contrast of the picture and sometimes to change the color. In conventional photography, flashing is sometimes used before the primary exposure to increase the effective ISO of the film.

The Effect

Photographers often talk about flashing as *fogging*. However, fogging can also mean an accident, the effect of certain diffusion filters on the lens, or the chemicals used to cloud the air. Other than the accidents, any of these are useful effects with some similarity in the results. Picking the right effect for the picture requires understanding the differences between them.

Flashing differs from other effects in two important ways. First, it primarily affects the shadow tones. Additionally, flashing does not affect the sharpness of the image, except indirectly to the degree to which contrast influences sharpness.

If we imagine the highlights in the primary exposure to be fully exposed film and the shadows to be absolutely unexposed, we see why flashing has maximum effect on the shadows. If the highlights are fully exposed, any additional exposure has no effect on the density of the image. If the shadows represent virgin film, the effect of flashing is fully visible there. Flashing affects the middle tones to varying degrees depending on their density. (Of course, no practical image has completely exposed highlights or completely unexposed shadows, but they approximate these ideals closely enough for our explanation to work.)

Flashing the film with white light is useful whenever contrast reduction might improve the scene. Slightly flashing an image to be used as a background for another one can increase the illusion of distance. Flashing one subject in a scene with a glow around it degrades detail as it might be if the subject were really glowing.

Flashing with colored light causes a color shift unlike any other because it adds more color to the darker parts of the scene. This influences the color of the highlights less than shooting the primary exposure with filters on the lens or on the lights. In the Street Crime photograph in the Rear Projection entry, flashing the background transparency turned the nighttime black to red without significantly affecting the yellow highlights.

Another example of flashing with colored light might be to add a partial sepia-toned look to a color photograph. A sepia-toned black and white print has color in place of the blacks and grays, but it also has clean whites. This resembles the result of flashing color film with brown light. Sepia filters do not produce this effect because they add too much color to the highlights and too little to the shadows.

Controlling Flash Exposure

We can flash any photographic emulsion. This sometimes means flashing paper while making the print. More often, however, we flash the film while it is in the camera. Film can also be flashed by an enlarger with no negative in the carrier. However, most flash exposures are very brief, and using the camera shutter and aperture adjustments allows better control of the flash exposure for most films.

Light tables and illuminated cards both make good light sources for flash exposures. All we need to do is to aim the camera at either of these evenly illuminated sources and expose the film. It does not matter whether we make the flash exposure before or after the primary one. Additionally, we may make the flash exposure with the camera extremely out of focus to ensure that no dust or other imperfections on the light source reproduce.

The amount of flash exposure can vary from just a hint of contrast reduction to an extreme degradation of the primary exposure. A good starting point is to meter the light table or the illuminated card as if it were an 18 percent gray card, and then give the flash exposure three to four stops less than the meter reading.

The effect of the flash and the primary exposure is cumulative. Slight flashing requires no adjustment of the primary exposure, but greater flash exposures may need up to two stops reduction in the primary one. Previsualizing the combination is difficult because the flash exposure has a different effect on each step of the gray scale. This means that a flash exposure that has a major effect on a low-key image may be just barely noticeable in a high-key scene. The right combination depends on what values in the scene matter most to the photographer. Polaroid testing is essential but not completely reliable because the Polaroid material does not perfectly match the contrast of the conventional film. The usefulness of Polaroid testing in predicting a color shift caused by flashing is even more limited.

Because a judgment based on Polaroid testing makes it easy to overestimate or underestimate the effect of flashing, it pays to look at Polaroids of the combined exposures and separate Polaroids of the flash and the primary exposure alone. Seeing the component exposures improves our evaluation of the test.

The only foolproof test of extreme flashing is the finished picture. Reshooting allows fine tuning. If reshooting the original scene is impractical, forego the flash exposure, and experiment with flashing while making a duplicate transparency of the original.

COLOR SATURATION

Color saturation roughly means the purity of the color. The term is defined as much by the psychology of the viewer as by the physics of light. Still more roughly, a highly saturated color looks like its name. Red looks red, not grayish red.

Several fairly conventional photographic techniques may increase the apparent color saturation: slightly reducing exposure; lighting the subject at an angle to avoid direct reflection or glare (diffuse reflection carries the color information); keeping the highlights white and the shadows black, with everything else as close to the middle values as possible (a moderate highlight or shadow mixes white or black with the color); copying the original (film reproduces some colors more brightly—an extra generation may exaggerate the effect). Probably none of these deserves to be considered a special effect.

Reducing color saturation is a more interesting effect. Photographers often minimize color by significantly increasing or decreasing exposure. If the subject is more black or more white, there is less color. However, neither of these techniques works if we want an image with a normal tonal scale. To reduce color saturation and keep the exposure normal, we need both a color and a black and white version of the picture. We then copy both of them on one sheet of film or paper, using one exposure from each version, in succession.

To produce **Figure 63**, we shot both color transparency and black and white negative material. Then we contact printed the black and white negative on line

film, processing the line film in print developer to get a positive. The result was two positive transparencies—one color and one black and white.

Next we registered the two images on the light table by eye. Taping one image at the top and the other at the bottom allowed us to swing either one aside without removing it or seriously misaligning it with the other. We exposed the final color transparency in a camera focused on the film taped to the light table. Diffusion on the lens during the exposure of the color image concealed the slight misregistration inherent in this method. Each exposure was about half that required for a single normal exposure. You may vary the proportion as you prefer.

We could vary this routine to suit the subject and for convenience. For example, had the scene not been a still life, we could not have made identical images on both originals, but we could still have made the black and white transparency from the color one. To keep the image sharper, we could have omitted the diffusion, contact printing with pin registration for precise positioning. We could also have made color and black and white internegatives from the original transparency to use to double expose color paper.

GRAIN

After years of asking the film manufacturers for finer grain film, looking for ways to increase the grain is evidence of both the creativity and the perversity of photographers. Nevertheless, the look of coarse grain can be useful. Noticeable grain gives a somewhat journalistic and therefore "real" look to the image. Extreme grain can also soften reality, making the picture look less photographic and more as though it were drawn or dreamlike.

Two Basic Approaches

There are two basic approaches to increasing grain: processing the film abnormally and adding simulated grain to a conventionally processed image. The first of these is getting more difficult every day.

Figure 63 Color desaturation. On the copy stand, one sheet of film received two exposures: one of an original color transparency, the other of a black and white transparency of the same scene.

Generations of film chemists have directed their talents at making film as grainless as possible, and they have been very successful. It is no longer easy to undo their accomplishments. Modern films are just too good. Another objection to chemically enhanced grain is its finality. There is no opportunity to fine tune the result. Furthermore, coarse grain always sacrifices sharpness whether we like it or not.

All of these reasons recommend simulated grain. The process is simple, fast, and very flexible. It is also philosophically sound: a hard-core special effects practitioner always prefers the fake to the real thing whenever there is a choice. The only tools needed are some sheets of paper and a can of black spray paint.

Making Grain Patterns

The first step is to spray the paint on the paper in the simulated grain pattern we want. This is where a bit of creativity comes in. By varying the kind of paper you use and how you spray the paint you can produce almost any grain pattern and effect you want. Perhaps the most important variation at this point is the size of the dots of paint you spray on the paper. The larger they are, the larger the grain will appear in the final print.

We may want to copy the painted grain pattern on line film of the same size as that used for the conventional image. For maximum flexibility, after we process the film we may also contact print it onto yet another sheet of film. By doing this we end up with both positive (black dots on clear) and negative (clear dots on black) versions of the grain pattern.

Adding Grain to a Conventional Image

We can add the grain pattern to a conventional image either by sandwiching or by multiple exposure. Sometimes the differences between these can be subtle, and preference is always subjective. The following guidelines are intended to mimic real photographic grain as much as possible. Real photographic grain is only minimally detectable in the shadows and the highlights, and these recommendations add as little simulated grain as possible to those tonal areas. If you see no need to mimic real photographic grain, ignore these suggestions.

The method we choose to add grain depends on whether we are working with a positive or a negative and on the brightness, or key, of the subject.

Working with Positives

If the subject is high key, composed primarily of white and other light tones, make a double exposure using the positive grain pattern (the one with black dots on a clear background). Expose the fresh film or paper with the conventional image alone and then the grain pattern alone. Whether we do this with a copy camera, with an enlarger, or by contact printing makes no appreciable difference.

If, on the other hand, the subject is low key, predominantly blacks and other dark tones, sandwich the **negative** dot pattern, (the one with clear dots on a black background) with the original transparency. Copy with a camera, project with an enlarger, or contact print to reproduce the sandwich as a single assembly.

Working with Negatives

If the negative is of a **high-key** subject, sandwich it with the **negative** dot pattern, and print from the sandwich. When the subject is **low key**, double expose it in either the camera or the enlarger with the **positive** dot pattern.

Figure 64 Double-exposed grain: first, the flowers were exposed, then the same film was re-exposed to a spray-painted grain pattern on a light table.

All of the methods that use double exposure will greatly reduce the contrast of the image. Lighting the original image with a higher ratio or increasing its film development time can partly offset the contrast loss.

POLAROID TRANSFER

The appearance of any photographic image is determined partly by the properties of the material on which it is printed. This is precisely why manufacturers make so many different kinds of photographic papers varying from smooth and bright white to deeply textured and almost yellow off-white.

Transferring a Polaroid image onto cloth, rice paper, watercolor paper, or another surface carries these possibilities even further. All of these are technically inferior to the intended receiver sheet packaged with the Polaroid film. But to many photographers, the consequent degradation has a charm and character of its own.

Figure 65 A conventional transparency sandwiched with a black spray-painted grain pattern.

The Process

Polacolor film can be used in any number of different ways to produce image transfers. That is one of the delights of the technique. Its variations are almost endless, providing an almost limitless number of possible results. The process we outline in the following steps is by no means the only one you can use. It does, however, provide a useful introduction. After that, the only limits are your imagination and your willingness to experiment.

Once this film is exposed, we normally pull it through the rollers in the camera or film holder to start development, allow it to process for the recommended time, and then peel the finished print apart from the negative. During the development time, dyes in the film migrate, or transfer, from the negative to the receiver sheet, creating the finished print.

If we want to transfer the image to a surface other than the intended receiver sheet, we must interrupt the normal dye transfer from the negative to the receiver sheet by peeling the film apart well before its normal processing time is complete.

Figure 66 A Polaroid transfer made by copying an original transparency on Polaroid Type 59, then transferring to watercolor paper instead of the receiver sheet packaged with the Polaroid film. Copyright Steve Biver, 1991.

The negative is then placed in close contact with a sheet of paper, silk, or some other surface, and the dyes in it are allowed to migrate from the negative to the surface instead of to the normal Polaroid print. The following steps assume we are using porous paper as a receiver sheet.

1. Prepare the receiver sheet. Immerse the sheet of paper for thirty seconds or so until it is completely soaked. Next place it on a clean, flat, dry surface and squeegee or blot with paper towels to remove the excess water. Once this is done, the paper is ready to receive the image.

2. Expose the negative. You may copy an existing image or shoot a new one. Select any of the Polacolor films that require peeling apart the negative and the positive after processing on the basis of the equipment and the size picture you want. Note, however, that the transfer process will not work with the Polaroid

films that combine the negative and the positive in a single sheet or with the Polaroid black and white films.

Because only about half of the magenta dye and very little of the yellow dye migrate during the transfer process, many transferred images have a decidedly cyan color bias. You can partly correct this by using 10 or 20 CC red filtration when shooting.

3. Process the negative. Begin processing normally. Pull the film through the rollers in the film back, or in the case of 8 × 10 film, run it through the processor to begin processing.

If you are using 4 × 5 sheet film, you will notice that a metal clip is used to hold the negative and the positive sheets together. The end of the film, just after this clip, is called the *trap zone*. It collects excess chemicals. After you have pulled the film through the processor you can then cut off the trap end just above the clip. This will help to get rid of any excess chemicals.

4. Interrupt the development. After the film has processed for about 10 seconds, peel it apart in the normal manner, discard the positive print, and save the negative. This is, of course, exactly the opposite of what you would do if you were using the film in a normal manner.

5. Make the transfer. Quickly place the negative face down on the damp receiver sheet. Then use your hand or a roller to press the negative firmly against the receiver sheet. Use an even pressure to distribute the dyes as evenly as possible. Wait for 90 to 120 seconds (depending on the type of film), then gently peel the negative away using one slow motion beginning at one end.

If you are using 8 × 10 film, you can use the manual technique we have just described, or you can use the processor to transfer the image to a thin receiver sheet. If you decide to use the processor, follow these steps:

1. Lift the chemical pod on the positive, and place the receiver sheet so that it covers the Polaroid positive.

2. Place the resulting bundle (the chemical pod, receiver sheet, and positive) in the loading tray.

3. Position the exposed negative on top of the bundle with the tab from the negative sleeve passing through the slit under the processing pod as it normally would.

4. Press the "start" button to begin processing. The processed image will transfer to the nonstandard receiver sheet covering the normal one.

It is important to stress that you must *only* use a thin sheet as a receiver when using the Polaroid processing system. A thick sheet will almost certainly damage the machine.

Once you have peeled the negative away from your print you can manipulate it as you like. This can be done while it is still wet or after it is dry. You can, for example, use a foam brush or knife to remove some of the dyes while the print is still wet. After the print has dried, you can use pastels, graphite, or charcoal to add color or accent. You can also use dyes, solvents, and watercolors to add or change colors while the print is wet or while it is dry. The potential for this kind of reworking is limitless; experiment in any way that interests you.

Once you have finished, the application of a neutral acrylic matte varnish will help to protect your print. Because of their often fragile nature and all the varied techniques possible in making them, there is absolutely no way of predicting how long a transferred image will last. With that in mind, shoot a copy transparency of any image you wish to be sure of preserving.

MASKING

Most photographers have combined images through multiple exposure or sandwiching. Both techniques are effective with the right subject matter and lighting. However, if foreground and background subjects have equal brightness, then either multiple exposure or sandwiching will spoil the picture by rendering the foreground subject transparent, as is the case with the cube in **Figure 67**.

Masking means sandwiching additional film with the film of the principal image to keep part of the scene from printing when the film is reproduced. Masking is the single most powerful special effects technique because any number of elements can be combined in any position and at any size in the photograph. In motion pictures, masking is more commonly called *matting*. The two terms are identical in meaning.

Using a Mask

We almost always need at least one mask for each piece of original film we intend to use to make the final picture. In the simplest cases this means a foreground mask and a background mask. Each of these overlays, or blocks, the part of the original film we do not want to print. **Figure 68** shows appropriate masks for the cube on the checkerboard we saw earlier.

The positive mask is registered with the background transparency, and the negative mask is registered with the foreground transparency. Figure 69 shows these two sandwiches.

We expose the film or paper to be used for the final picture twice—once with each of the two masked transparencies. One exposure produces the foreground subject, the other the background. After processing, the result is a combination of the original elements in a single scene.

At its simplest, masking requires five pieces of film or paper: two originals, two masks, and one final composite. All of these must register perfectly with one another. Pin registration is essential throughout the process. Furthermore, each exposure is usually made with the original in contact with the raw stock; few enlargers and cameras are steady enough to allow repeat exposures without moving slightly out of position.

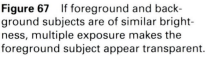

Figure 67 If foreground and background subjects are of similar brightness, multiple exposure makes the foreground subject appear transparent.

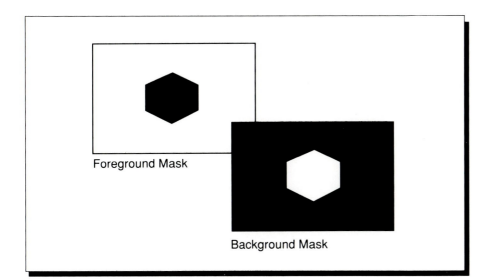

Foreground Mask

Background Mask

Figure 68 Masks cover part of the scene to keep it from reproducing.

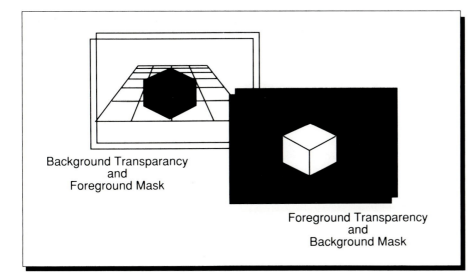

Background Transparancy
and
Foreground Mask

Foreground Transparancy
and
Background Mask

Figure 69 The cube and its intended background, masked so that the detail of one cannot superimpose over the other when they are reproduced.

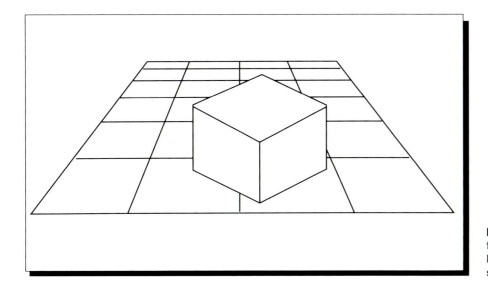

Figure 70 Successive exposure of the fresh film or paper to masked originals keeps the appearance of the foreground subject opaque.

PRODUCTION SUMMARY

Dali Vista

The table is real, the wall is a hand-built miniature, and the sky is painted canvas. The scene through the window is a different canvas, illuminated neutrally. The sun is a hole in a black card, photographed with heavy diffusion on the lens.

Five principal pieces of film and their associated masks were used in the long list of steps required to produce this image. We will examine only one group of them; the principles are the same for all the rest.

The foreground table is photographed against a black background, with sand heaped on its back edge to help blend it with the scene to be added later. We normally would prefer to photograph such a dark subject against a white background because the clearer edge definition would make it easier to produce a mask. But in this case, the candles require the black background; flame cannot be photographed against pure white. In addition, black is self-masking.

The table scene, contact printed on line film, produces a foreground mask for the table. However, the lack of clear edge definition means that painstaking hand retouching is needed to replace missing parts of the subject before the mask is usable.

The second photograph shows the table transparency and the foreground mask associated with it. The two are never used together. To produce the final transparency, the table transparency is copied on a light table. No background mask is necessary because of the black background. The table transparency is then removed from the light table, and the foreground mask is pin registered in front of the camera where the table used to be.

Diffusion material is laid over the mask to make its edge more realistic. The diffused mask is left in place for all subsequent exposures so that the final film receives no further exposure in the area where the table is.

Copyright Bill Dempsey, 1991.

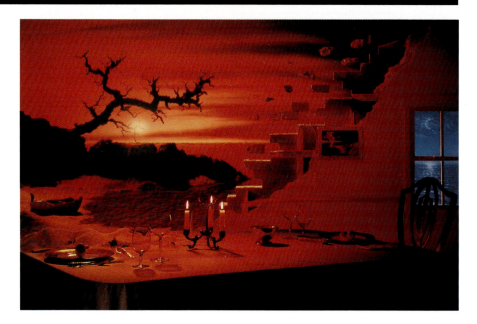

Making a Mask

The easiest way to make a mask is to contact print the basic film onto a piece of lithographic film. Anticipating the need for a mask and lighting the original scene accordingly greatly simplify producing the mask. For example, if the foreground subject is shot against a pure white background, contact printing the original transparency onto a piece of lithographic film produces a background mask. Contact printing the background mask onto another piece of lithographic film then produces a foreground mask. Together, the foreground mask and the background mask allow the original subject to be inserted into any scene.

It is important to understand that this sequence of steps is only one of several possible variations. If, for example, the original subject was bright, we would have shot it on a black background. Contact printing the original would then have produced the foreground mask first, instead of the background mask. Sometimes some of the highlights or shadows in the subject match the background. In those cases, retouching the mask is essential.

After the original transparencies are processed, we punch them for pin registration. At the same time, we punch a supply of unexposed lithographic film to use for the job. Alternatively, we may punch a supply of acetate sheets and tape the transparencies and masks to them.

Softening the Mask

The lithographic film produces an image so sharp that the boundary line between the subject and its background is likely to be sharper than anything else in the scene. Unless both the foreground subject and its intended background are extremely sharp, the difference in sharpness reveals the trickery to even the most naive viewer. To make the mask believable, we have to keep it from being too sharp compared to the rest of the scene.

We do this by sandwiching a piece of diffusion material between the original and the mask. If we are contact printing, the original goes at the bottom of the sandwich, and the mask goes on top. Reverse the order for copying a rear-illuminated original. In either case, the diffusion goes in the middle of the sandwich. This softens the sharpness of the mask slightly, but it does not reduce the sharpness of the original image. The result blends the edges of the foreground and background subjects slightly. The blending also conceals slight misregistration. Skillfully done, the effect is identical to photographing the foreground and background in a single scene.

Extremely Soft Masks

In many cases we do not need precise masking of the subject. One example of such a situation would be if we wanted to add slight density to a black background or to extend its area. In such cases, masking a general area of the scene, with no clearly defined boundary between the masked and unmasked areas may be adequate. Airbrushing a soft-edged shape on acetate can produce such a mask without line film or lab work. Whenever a soft mask is adequate, it is easiest to use because even gross misregistration is unlikely to be noticeable.

Garbage Masks

Special effects often require extraneous supports and gobos in the scene that we do not want to see in the final picture. Plan the shot to keep such clutter against a black background. Then sandwich the transparency with a *garbage mask*. We

generally need only the foreground version of a garbage mask, and it may be an extremely soft airbrushed one if the offending element does not touch the subject.

Advantages and Disadvantages of Masking

Masking an image in the laboratory sometimes produces a photograph indistinguishable from multiple exposure, in-camera masking, or some other image combining technique. In those cases, which is preferable? It is worth listing some of the arguments for and against masking. The weight of each argument varies with the job.

Advantages

1. Versatility. Masking can be used with almost any scene and with almost any background. Multiple exposure in the camera usually requires a black background. Multiple printing of negatives requires a white one.

2. Quality. Each picture element gets only one exposure during reproduction. Re-exposing an area of the film or paper always increases general fog slightly.

3. Safety. When special effects are produced in the camera, a single error usually means reshooting the whole job. Masking allows us to keep the elements of the scene separate until they get to the lab. Errors are easier to correct in the lab if each shot contains only one element. If the error cannot be fixed, only the part of the scene with the problem needs to be reshot.

4. Reduced shooting time. Photographers can accomplish more if part of the work is transferred to the lab. Sending the models and stylists home sooner cuts costs.

Disadvantages

1. Difficulty of previsualization. The photographer cannot see the image produced by masking techniques until the lab work is done, often days later. Producing an effect in the camera allows us to closely approximate the final product with a Polaroid at the time of the shooting.

2. Possible elimination of "real" optical effects. If the subject is not in the background scene, it cannot cast a shadow there. Transparent subjects do not have the background visible through them. Glossy subjects do not have the rest of the scene reflected in them.

3. Lack of control by the photographer. An experienced photographer usually has a better eye for realism than anyone else working on the project. Masking techniques require putting some creative decisions about exposure, color balance, and contrast in the hands of the lab technician.

PIN REGISTRATION

Pin registration uses precisely manufactured pins inserted through carefully punched holes in film or paper to ensure accurate repositioning of the stock during any process requiring repeated exposure. The technique is usually used with masking so that raw stock can be exposed, first with a foreground subject and then with a background subject.

Preparing a job for pin registration requires that we punch all materials to be used with a registration punch. Less critical applications allow us to use an ordinary multiple hole paper punch as a registration punch. More often, however, we use a special punch intended for pin registration. The special punch is identical

Figure 71 Identically punching each piece of film to be used in the assembly allows perfect positioning of each on registration pins.

to the office variety in principle, but it is more rigidly constructed; the result is that the distance between the holes changes less with repeated use of the punch. Punches intended for registration also produce smaller holes that interfere with less of the usable image area. Registration pins are manufactured to match either hole diameter.

In **Figure 72**, registration pins are inserted through holes in a transparency and its mask. After the two are registered with one another, the flat plates on the registration pins are taped to the contact frame or the light table.

After the exposure, the pins are left attached to the contact frame or the light table, and the first original is removed. Another masked transparency replaces the first for the next exposure. Used carefully, the pins ensure that the next image is positioned identically to the first.

Although pin registration is most frequently used in the lab, some photographers modify conventional large-format cameras and film holders to allow pin registration in the studio. In those cases, the film is not usually punched. Double-backed tape in the film holder maintains the film position at least within the limitations of precision imposed by most camera stands. Instead, the edge of the film holder is drilled to accept pins installed in the camera. This allows removing the film holder and re-exposing the film in another camera with identically positioned pins. This arrangement eliminates the play common to the spring backs of most

Figure 72 A transparency and its mask, registered with pins.

view cameras. Such camera modifications allow trial and error registration testing with Polaroid film. When the setup is right, we can expose the conventional film and expect the registration to match the test.

Notice, however, that pin registration in the camera only offers a practical benefit if the photographer is using a Polaroid magazine that has a dark slide. Polaroid film types that cover the sheet of film with a paper envelope permit too much movement of the film as the envelope is pushed in and out. Even if the Polaroid holder is drilled for positioning identical to the conventional film, movement of the film inside the holder prevents any improvement in accuracy.

ELECTRONIC IMAGE MANIPULATION

With a flick of a switch, a twist of a dial, and a slide of a mouse, the electronic revolution has entered the photographic industry. In any magazine or any newspaper we will find examples of images that have been manipulated by computers, whether we realize it or not. Electronic image processing is usually nothing more than simple cosmetics. In those cases the electronics simply replace the time-honored airbrush on its mercy mission of retouching a skin blemish or a sagging chin line. At other times, however, electronics are being routinely used to remake an image completely or to create one that never before existed. The electronic capabilities are infinite, and the range of manipulation is limitless—for anyone with the budget to buy the service.

The Basic Procedure

New equipment, new software, new capabilities for electronic image manipulation appear every month, and as general-purpose office microcomputers become more powerful, we see more and more image processing programs written to run

on hardware originally intended for word processing and database management. But no matter what kind of a system it is or who makes it, all electronic-imaging systems share some common principles. They all must perform three basic tasks:

1. Loading the image or images to be manipulated
2. Allowing an operator to manipulate the image
3. Outputting the resulting image in some form

Because of the investment cost, not everyone involved in electronic imaging owns equipment to do every step. It is not unusual for someone performing the manipulation—the creative step—to buy the input and output services elsewhere. Thus, part of the system may be in another part of the city or even in another part of the country.

Loading the Image

The process of electronic image manipulation begins with loading the original images into the system. This usually requires the use of an image scanner. Scanners are photoelectric devices that convert an image into a digital electronic signal—a series of electrical ons and offs intelligible to a computer. The digital signal can then be copied to magnetic tape or disk and stored for future use, or it can be displayed on a monitor and edited immediately.

One of the major advantages of digital data is that it can be copied endlessly without any change or distortion. The very nature of digital signals ensures that they can be reproduced time and again without being altered in any way. For the first time in the history of photography, we need not fear losing quality by successive generations of duplication. Not only does this mean that electronically scanned images can be easily duplicated, it also means that an image or any part of it or any of the visual elements in it can be stored and reused any number of times by any number of people in any number of places.

A wide range of scanners is available. Some are simple and relatively inexpensive devices capable of handling nothing but black and white prints. At the other end of the expense scale are sophisticated color scanners that can process color prints and transparencies of any size from 35mm slides to 8x10 sheet film.

Other devices allow images to be captured directly from television broadcasts or previously taped material. Often called *frame grabbers*, these devices make it possible to integrate anything shown on television into any still image. It is also possible to obtain images already digitized from a growing number of electronic libraries. These services are making them available on disks and, sometimes, by modem transmission. This trend is sure to grow in the future, especially as the increased use of fiber optic telephone lines in the twenty-first century enables higher speed transmission of the large amount of data required to store a photograph.

Manipulating the Image

Once the images are loaded into the system the fun can begin. At this point there are literally no limits to what can be done to them.

Figure 73 shows the result of one basic and much used type of electronic manipulation. This demonstration was electronically assembled from studio photographs and illustration. The resulting picture is different from any of its individual parts, and it would have been impossible to produce using nothing but conventional in-camera techniques.

Electronic image processing does allow alteration of the shape of the subject by stretching or distortion. However, too much distortion of a familiar subject

Figure 73 Updated Escher. Electronic image processing by Dodge Color, Inc.

such as a hand is quickly apparent to the viewer. Like photomechanical assembly, electronic assembly is most effective if the photographer anticipates the final result and shoots to fit. In this case the photographer began by putting the camera on a copy stand and tracing the original Escher drawing on the ground glass. With the ground glass tracing as a guide, the photographer photographed the hand with the stylus to match the perspective and posture of one of the hands in the drawing as closely as possible.

It is easier for the system to find the shape to be lifted from the photograph if the background is uncluttered and of a value that contrasts to that of the subject. The photographer believed the black stylus was more likely to cause problems than the white shirt and so used a white background. If a scene with its required lighting has subjects too dark to distinguish from a black background and subjects too light to distinguish from a white background, use a gray one. If the outline of the subject is extremely complex, i.e., a closeup of hair, use a background of a color similar to that in the scene with which the subject is to be married. Then, if the software and the operator accidentally fail to remove a bit of background, it is less likely to be noticed by the viewer.

Figure 74 *Drawing Hands.* The top hand was used in the bottom of the electronically created composite. Copyright 1948 M.C. Esher/Cordon Art-Baarn-Holland.

Figure 75 The principal photograph used in the Figure 73.

The photographer made two additional photographs on separate sheets of film: a computer monitor against a black background and a speckled glow, similar to the one around the tip of the airbrush in the "Glows" entry of this book, to be added to the tip of the stylus.

The computer operator married all of the photographic images then created the rest of the scene entirely electronically. Finally, he decided the photographic glow was not working properly with the stylus, so he removed the existing glow and created a new one that was not based on any photographic image.

Isaiah 2:4

Conceived during the Gulf War, this picture illustrates the comments of the noted political analyst and Middle-East expert who predicted, "They shall beat their swords into plowshares." Attempting a realistic image of an impossible event required photography and illustration. The computer was the perfect vehicle to marry the two. We made five transparencies:

Transparency 1: The AK-47 assault rifle, conventionally illuminated.

Transparency 2: The same rifle, with the lens covered by an orange gel sprayed with clear lacquer for heavy diffusion and color shift. A small spot with a red gel is directed at the muzzle for additional illumination and color. This was used to produce the glowing metal barrel.

Transparency 3: The plow with red illumination from the left and a neutral fill light.

Transparency 4: The plow again, now photographed through the same lacquered gel used for the glowing metal gun barrel.

Transparency 5: The background— anvil, flags, hammer, and smoke — received two exposures on one piece of film. Ambient illumination was established by a neutrally colored overhead bank. Illumination by the glowing metal was then simulated by a light source covered by an amber gel, focused on the foreground flags and the front of the anvil, and shot with light diffusion on the lens.

The computer operator assembled pieces of each transparency for the final image. All five images blend in the area where the gun barrel meets the plow. Notice that although the gun is the foreground subject where it rests on the anvil, it has been manipulated to become a background subject where the stock passes beneath the smoke.

Electronic retouching included adding the slight shadow that would have been produced on top of the anvil if the gun were really there, and rearranging the golden highlights in the foreground to positions where they might have been had they been produced by glowing metal in the scene instead of a studio light just outside of it.

Electronic image processing by Dodge Color, Inc.

Outputting the Product

Once the electronic wizardry is finished, the only thing that remains is to generate the result. This is done by sending a digital signal representing the final image to an output device that decodes the signal and translates it to a beam of light. Depending on the device, the light emitted may expose continuous tone film for a negative or a transparency, four sheets of line film for color separation, or photographic printing paper.

The Sky's the Limit

The examples shown here are representative of the possibilities of electronic image manipulation and are certainly not a comprehensive catalog of the capabilities. Consider this an introduction to the field and an invitation to begin considering electronic manipulation if you are not already doing so.

Modern electronic systems make it possible for a skilled operator to do just about anything to any part of any image. Colors can be changed, shapes distorted, and proportions adjusted almost as fast as the hand can move across the control panel. The only real barrier a photographer faces is money.

The computers used to process image data are expensive. This is even more true of the scanners and the output devices. The hundreds of thousands of dollars of investment that they represent translates into high hourly fees for their use. Whether your budget or your client's budget can afford the service depends on how much time your specific image requires. Any cost guidelines we might give here would be obsolete by the time you read them. When you consider making a photograph using these manipulations, talk to the lab. If you cannot afford it, do not be discouraged. New hardware or software may speed up the job and make it affordable in another six months.

Future Trends

It is hard to predict the future of electronic image manipulation. As the power of personal computers has grown in recent years, their ability to handle sophisticated image manipulation has increased dramatically. This trend promises to eventually put the hardware into the hands of every photographer.

At the same time, the labs want to stay in business. To do so, they are likely to implement more and more sophisticated systems as fast as they can afford them. As the systems become capable of doing more, better, and faster, client expectations will also rise. If what we consider to be the minimum requirements of a system keeps getting better, then owning that system will remain beyond the average photographer's financial reach for a long time.

So either we will all own the system or we will have to keep buying the service in the progressively better versions available. Either way, it's going to be fun!

INDEX